# THE PHOTOGRAPHIC EXPERIENCE

# THE
# photographic
## EXPERIENCE

jeff berner

**ANCHOR BOOKS**
Anchor Press / Doubleday, Garden City, New York    1975

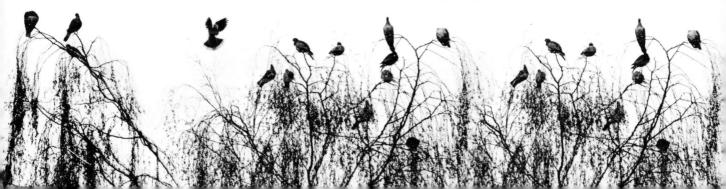

The Anchor Books edition is the first publication of *The Photographic Experience*.
Anchor Books edition: 1975

Design & typography by Jeff Berner and Barbara Rasmussen

COPYRIGHT © 1975 BY JEFF BERNER

ALL RIGHTS RESERVED

PRINTED IN THE UNITED STATES OF AMERICA

FIRST EDITION

*Library of Congress Cataloging in Publication Data*

Berner, Jeff.
    The photographic experience.

    1. Photography. I. Title.
TR183.B46      770
ISBN 0-385-01773-1
Library of Congress Catalog Card Number 74–12723

*Behead yourself!*
*Dissolve your whole body into Vision;*
*Become seeing, seeing, seeing!*

Jalal al-Din Rumi (1207–73)

For my parents

And with warm appreciation to Joe and Irene
McHugh, Rolf and Jean Scherman, Walter Klink,
Stephanie McCaffrey and Valerie MacLean

# CONTENTS

# PREFACE

I am interested in natural light. Moonlight, firelight, lightning, sunlight,-or anything that glows. The first photographers called themselves "sun artists," and through the eye-joy of camerawork I am able to study and share the qualities of light and the meaningful things that are wrapped in it.

Photography is intuitive, non-verbal, and is its own reason for being. But it happens that any creative activity gives rise to "philosophical" thinking, sometimes during the action, but more often upon reflection. This book is not intended as a philosophy of photography, but rather a sharing of my personal voyage of discovery through the medium, and the ideas it has stimulated during some years of photographic exploration and expression.

I trust the reader will bear in mind that the projects or suggested approaches in the following chapters are offered only as personal *aha!* experiences rather than as definitive statements on photographics, as one must remember that a rule of thumb may not apply to the other fingers.

Looking for contributions to the education of vision, I have ranged far afield, from quotations of poets living seven hundred years ago to observations of contemporary photographers. What they all share is a passionate love of seeing, and therefore of the world.

I was sitting at the desk in my studio overlooking the garden, enjoying the view and tickling the typewriter. The phone rang, and the voice of my four-

year-old neighbor Derek, who had somehow gotten my number, came through. "What are you doing?" he asked. Putting on my best W. C. Fields tone, I replied, "Derek, I'm writing a book about photography." Whereupon he bubbled, "Oh! I can read photography!"

In a sense, that is what this book is about.

Jeff Berner
*Mill Valley, California*
*April 1974*

# THE PHOTOGRAPHIC EXPERIENCE

# Light

Five hundred million years ago, the trilobite appeared. It had compound eyes of a thousand facets each, and was the first creature on the planet to see. What it saw was light-contrast and motion, but not pictures. The fireball sun, roiling in the sky, bathed Earth in life-giving energy.

The sun, like the eye, makes things visible, and the sun to ancient Egyptians was the eye of the god Ra. They built temples to the worship of light, and by carving bas-reliefs into stone utilized the changing shadows of the day to animate their art. Some temples had no roofs, and a whole city was named "The Realm of Light."

The human eye has one hundred twenty million rods in each retina to perceive light, with a single lens in front to focus the inrush of energy into images. Its range of sensitivity is vast. In the gravest darkness, the eye can respond to merely one ten-billionth the amount of light it can receive in brightest daytime. Two or three quanta of light are enough for a sensation to register in the brain. One quantum of light decomposes one molecule of the eye's photochemical. It requires almost nothing to tickle the interest of the human eye.

In ancient Greece, Plato wondered: Does light come into the eyes or do the eyes broadcast light into the world? Supposing the eye itself is a light-source can be an exciting way to think about seeing as a creative act. Modern

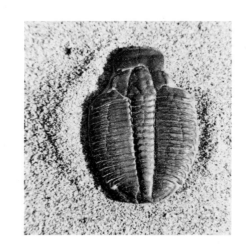

psychology has demonstrated how we often project what we want to see upon the world. When the world is taken away, in experiments in which people have passed long hours in total darkness, in every instance the subject begins to "see" trees, faces, clouds, or whatever is needed to re-create a living surrounding for himself. As nature abhors a vacuum, so the human mind will not allow for nothingness, and constantly projects life into every corner.

Light, in all cultures and religions, represents life itself. Darkness has held the terrors of the soul. The great cathedral at Chartres and the Blue Mosque in Turkey are perfect examples of architecture used to funnel divine light into the human realm.

Light bounces off everything as the eye receives waves echoing everywhere and integrates them into pictures. Waves? Western science has long debated whether light is waves or particles. It behaves as both, and is subject to gravity. Tibetan Buddhists see existence as a continuous flow, a river of being, which *also* manifests itself as separate flashes of energy, a strobe light flickering so fast it appears to be uninterrupted. Light as wavicles!

In the seventeenth century, the mirror represented infinity, eternity, because it reflects everything. Film is a mirror in the camera, and the mind of the observer also reflects what it sees.

Darkness has its "dark associations," but it is the interplay of light and dark

which reveals the sculptural quality of objects, as the Egyptian sculptors knew so well. Shadows playing with the edges of light make visual music, with rhythms and intervals. Darkness is to light what silence is to sound.

We have briefly touched on ideas from ancient Egypt, Greece, and Tibet. Light is also ancient, as the rays leaving a distant star can take numberless light-years to reach our eyes. It can take so long that the star we finally see can be many trillions of miles away from its position of broadcast.

Another sense of light comes from nineteenth-century England. The Prescription Act of 1832 provided that the owner of any building could post a sign declaring that he has a right to the light coming from adjacent property, and that no other building could be erected there without his consent if it would interfere with his light. According to this law, light is ancient if it has flowed uninterrupted for twenty years.

The trilobite of half a billion years ago began the long journey of evolution toward our own vision, as this corner of the created universe strained through the eons to see itself.

The sun is a vast engine of light, our own personal star.

You get a star-tan at the beach.

# The First Photograph

Humankind has always been interested in making pictures of the world, at first on cave walls and in the sand, later on pottery, buildings, metals, wood, glass, paper, and even on living skin. The eye reflects its surroundings, and enshrines experiences by translating *im*pressions of mind into *ex*pressions of the hand that holds the stick, the sharp rock, brush, pencil, or pen. But one thing drawings, carvings, and paintings are not: mirror images of external reality.

The first technique for projecting a real image against a flat surface, for study or tracing, was the camera obscura. The earliest published diagram of this "dark room" was drawn by the physicist and mathematician Giovanni Battista della Porta in 1558, although Aristotle had realized the theory behind it in the fourth century B.C.

The camera obscura is a dark room with a small hole, or shutter-window, in one wall, through which an upside-down image of the outside view comes in on a stream of light striking the opposite wall, where the viewer can see it as he sits inside. A white screen was often used to enhance the image or to trace on. Leonardo da Vinci's student Cesare Cesariano described one in print in 1521. Leonardo was aware of it, to be sure, as his own notebooks contain two descriptions. The eleventh-century Arab scholar Alhazen gives a clear description in his work on optics. The history of this image-catching device,

whether as a room for sitting or a smaller, portable box for peeking into, is long and interesting, as it aided in drawing and architecture well into the nineteenth century and was commonly used by educated people as a tool for painting and popular recreation.

But no matter how effectively the camera obscura gathered images, they still could not be taken out of the box. The urge to "stop the world" was very strong.

The invention of the photographic camera was an improvement on the simple design of the camera obscura. The alchemical story of preparing various materials such as pewter plates, glass plates, and sheets of paper, in order to sensitize them to light, was punctuated by hazardous experiments with chemicals that often ruined the health or killed some of the inventors of the early-nineteenth century. Mercury vapor poisoning was not unusual.

In 1826, Joseph Nicéphore Niépce, a French Army officer, caught a view from his workroom window on a pewter plate inside a professionally made camera supplied by a Paris optician. The view included a pigeon house, a pear tree, the roof of a barn, and a wing of his house. His chemicals were a coating of bitumen of Judea dissolved in oil of lavender, which hardened wherever light fell upon it and stayed soft and washed away in the dark areas. The solvent was oil of lavender with turpentine. The exposure for the world's first successful photograph took eight hours.

8

So the little dark box advanced toward us with a new ability: It could not only focus an image with greater clarity with the addition of a lens, but it could fix that image for our perpetual gaze. Pictures so captured were called by Niépce heliographs, or sun drawings.

In 1829, Louis Jacques Daguerre approached Niépce and they formed a partnership of their respective researches. Daguerre was an experienced theatrical designer and co-inventor of painted views on semitransparent canvas, the Diorama, which created an animated illusion for fascinated audiences. What he contributed to the photographic process was the shortening of exposure times for making pictures, from eight hours to twenty or thirty minutes, by the use of mercury vapor. Another eight years passed before he discovered a method of fixing images with a mixture of common salt. The images of daguerreotypes on copper plates, and later on glass, were and essentially still are unexcelled in absolute clarity.

"The wish to capture evanescent reflections is not only impossible . . . but the mere desire to do so is blasphemy. God created man in his own image, and no man-made machine may fix the image of God. Is it possible that God should have abandoned His eternal principles, and allowed a Frenchman in Paris to give the world an invention of the Devil?"

That was how a Leipzig newspaper responded to the announcement of the

daguerreotype, the first really practicable method of photography. It is interesting to note that the announcement was made at a joint meeting of the Académies des Sciences and Beaux-Arts at the Institut de France; from the beginning, photography was a coming together of art and science, spirit and matter. Within a week of the official birthday of photography, August 19, 1839, opticians' shops all over Paris were swamped with orders for what Oliver Wendell Holmes would later call "the mirror with a memory."

Some painters were delighted to have the new tool, while others moaned, "From this day, painting is dead!" Ten years later, an annual sale of two thousand cameras was reported in Paris alone.

Other experimenters, such as the inspired English tinkerer Henry Fox Talbot, were fixing images on paper, and quickly came forward with their techniques. Talbot, who invented the modern technique of negative-process photography, was a classical etymologist studying principally pre-Homeric languages and mythology. The essentials of the negative process came to him in 1835, and by 1840 he had dubbed it "calotypy," from the Greek *kalos*, "beautiful," and *tupos*, "impression."

With the daguerreotype announcement, photography became an overnight avocation for thousands. By 1853, there were ten thousand American daguerreotypists, and they made three million pictures that year. Portrait

studios popped up everywhere, and rolled in wagons, too. Everyone wanted his likeness on a calling card for a gift or souvenir. By 1861, people were talking about "photomania."

But the cameras and chemicals needed to make photographs were still cumbersome and, in some ways, chemically dangerous. This problem was solved by George Eastman when, in 1888, he introduced a small Kodak, the first camera to use roll film rather than sheet. This mass-produced box camera held one hundred exposures. You could take a picture at a mere one twenty-fifth of a second, saving many a stiff neck. And by sending the unopened camera full of exposures back to his factory, there was no messy work for the amateur. "You press the button, we do the rest," proclaimed the ads.

Pressing the button had great appeal in the closing years of the past century, when the machine age had captured the imagination of the world, excited by the apparent promise of applied technology.

With the advent of popular photography, everyone could be a family historian, arresting time with the little box.

It was thirty years from the moment the first photograph appeared until the University of London introduced the first course in photography, in 1856. Today, there are courses in the art and craft at over seven hundred univer-

sities in the U.S.A. alone. Currently, forty-two million Americans are photographers of one sort or another. Amateurs take five billion pictures a year, or about 158 shots per second!

This "tool of the devil," as the *Leipziger Stadtanzeiger* called it, has produced a Pandora's box of images since its invention a scant one hundred fifty years ago. It has greatly enlarged our powers of observation, and provided us with our first time machines.

A popular movement toward self-consciousness and social consciousness became a reality.

We had stopped the world.

# Looking at Seeing

Every moment is a point in experience. Looking into the world provides information for navigating the narrows and rapids of life as well as its peaceful lakes. When mere looking evolves into the art of seeing, we experience deeper revelation and perhaps even understanding.

The camera is a craft tool for translating moments of recognition into photographs that endure as objects for contemplation and communication.

Walking along the street, turning a corner, and suddenly seeing a familiar face is a moment of recognition we all know. When the eyes are open, the head is open. The cells of the retina are structurally like those of the brain itself, so the eyes are the one place on the human being where the brain sticks out! The photographic art becomes a living exercise in recording moments of recognition, as the eye guides the camera and the camera surprises and educates the eye. Even if we have never seen the particular face on the street before, we can still "recognize" it, as we recognize a tree, a cloud, the wag of a dog's tail.

Cartier-Bresson, a master of black-and-white photography and sometime film-maker, speaks of "the decisive moment." There are expressive moments and passive moments in the human drama. Even objects have their moments, as a just-noticed object jumps out at us, becoming somehow alive in our attention. A still life is still life.

The way visual attention works is an expression of the inner spirit of the photographer. When the camera eye is attracted to this person or that thing, to this bird or that color, texture, movement, it is saying, "I recognize you." One photographer may recognize the many levels of warfare, and another may devote a lifetime to the study of flowers. The visual taste buds naturally express acceptance of our individual relationships to the symbols and experiences of our lives.

"Out of sight, out of mind" is an old saw that has inner truth. It is well known that nearsighted people tend to notice what is near, and the farsighted see more distant aspects of a scene. Psychologists have found, not surprisingly, that the nearsighted are somewhat introverted, and the farsighted tend to be more expressive. Such visual biases are primarily physiological. Other seeing habits have cultural origins.

Our Western world is linear, with rectangular rooms, parallel streets, lots of corners in art and architecture. The Zulus of Africa, whose world is dense forests with no horizons in sight, have a "circular culture." Their huts are round with round windows, they plow in curves, and their handicrafts are rarely made with corners. Zulus who were tested on Western optical-illusion drawings didn't see the illusions, as their ancestral visual vocabulary doesn't include the same "words" as ours. When deep-forest people are taken out

into deserts and other open spaces for the first time, they don't experience distant objects as really far off. Instead, they see them as *very small* things. In all known primitive art and all the art of previous civilizations, there was no sense of perspective until the Italian Renaissance.

For the photographer, visual biases can be used to develop a personal style, but they can also represent a subtle trap for the creative artist, just as any habit can limit consciousness. Change, experimentation, and play are essential to the forward motion of the photographic journey.

> "As certain as color
> Passes from the petal,
> Irrevocable as flesh,
> The gazing eye falls through the world."

These words, written in the medieval heights of Japanese poetry by Ono No Komachi, express the movingness of the human cyclops. Hans Arp, a modern artist of rare simplicity, once said that the main reason people even bother to walk around is in order to have visual adventures.

Looking is a gift, but seeing is a power. We speak of "the powers of observation." In this regard, consider the question of visual bias imposed not by an accident of physiology or the inheritance of culture, but by the use of

different lenses. It's the problem of "seeing the third horse": On a photographic safari into a bright foggy afternoon in Marin County, California, a friend and I drove along the edge of a ranch where a few gray and beige horses were standing ghostlike in the mist. I am always drawn to situations in which color film can be used in a delicately colored, basically black/white/gray/beige scene. Using a 205mm telephoto, I concentrated on the radiant hides, steaming nostrils, and the immense quiet of two horses. My friend was at a different part of the fence, using a standard lens. Days later, when we projected our slides, his pictures had three mares, one more than I had seen. The third horse had been there all along, just a dozen yards away. A major challenge in the art of seeing photographically is using the tension between the power of things to fascinate us, and our powers of observation.

Sight is the dominant and most sophisticated of the five senses. We receive from 70–90 per cent of our information through the eyes. Two massive optic nerve tracts, each carrying fibers from both eyes, branch out toward the two hemispheres of the brain from the optic chasm, a junction just behind the eyes. Each of the millions of fibers carries information from a single cell in the eye to its counterpart in the brain. The eye/brain integrates the several hundred million visual fragments it receives into a coherent, flowing movie. As images enter the eye, they are received upside down, and are righted

mentally for reasons totally unknown. In experiments with "funny glasses" designed to turn the image upside down *before* it gets to the brain, test subjects were at first confused. But, after a prolonged period of navigating in an apparently upside-down world, the brain *again* tumbled the picture and "put the world aright," reversing the effect of the glasses.

Another peculiarity of sight is that of the lingering image. In old-time thriller movies, there are occasional episodes in which a murder victim's eyes are quickly examined in the hope that the assailant's image will still be on the retina. In fact, this is an actual phenomenon, as images have been seen on the retinas of just-killed rabbits, although it lasts for only a moment. An extreme example of the lingering image are the sunspots that stay with us sometimes for minutes after an overlong look directly at the sun. In this case, the rods have been "withered" by the blast of light, and take time to recover, much as the impression of a footprint stays for a time on freshly cut grass.

As well as our ability to look outward, we carry within us a retinal circus, an inner landscape. Almost everyone has "seen stars" resulting from a blow to the head, from fevers, or from simple dizziness. These are phosphenes, caused by the feedback between eye and brain. They can be easily stimulated with the eyes closed by gently rubbing the lids, or by turning the face toward a shower nozzle. The result is a full-color light show. Circular forms appear by

pressing lightly with the fingertips near the inside corner of the eye for a few seconds. Increased pressure will yield more-complex patterns, like spider webs. This inner kaleidoscope is best seen in the dark, but is also available in daylight. The most essential ingredient, however, is extreme gentleness with these delicate organs.

While we are inside, we should not forget that an enormous amount of visual and pictorial matter is observed in dream-space. Here we seem to be at the mercy of the dream, in no way controlling our attention. And whether we dream in black and white or in colors is also up to the dream. It is thought that only about one person in twenty has frequent color dreams. In rare instances of dream mastery, the sleeper can tell himself he is dreaming in order to center or redirect the images. Dreams often reveal things that would be too much to deal with if they happened during waking life. Bringing images back from the inner eye can be a rich source of study, which we will explore later. Sleeping or waking, life itself has been called "the insatiable dream."

When we have found our eyesight, it is but a short distance to the heart. "I see what you mean" says, "I understand." A visionary is someone who can foresee the future, which is really understanding the present. We can move beyond sight to insight.

Moholy-Nagy, who taught the education of vision at the New Bauhaus, in Chicago, predicted in 1937, "The illiterate of the future will be . . . the person who cannot photograph."

# The Psychology of Lenses

Using different lenses is a study in how optics affects relationships to things and with people. Lenses *reflect* and *affect* experience in the living surround.

A lens is a single spherical piece of glass scientifically ground into a series of tiny prisms. Most modern lenses are groupings of glass elements that correct each other's aberrations. The distance between a lens and the point where reflected rays from a distant object meet is the focal length of that lens. Where the rays meet is the focal plane; in the case of the camera obscura, it would be the interior wall opposite the pinhole.

The light-concentrating power of lenses is dramatically demonstrated by an ordinary magnifying glass turned at an angle in sunlight. The bright spot of light projected through this simple lens is a tiny picture of the sun. Such a "picture," when concentrated for a few seconds, can fire up paper and dry leaves, as any schoolboy knows. Photographic lenses likewise burn images into film.

The standard lens is usually 50mm or 55mm and records with lifelike proportions. I used such a lens exclusively for the first four years of my Pentax life, which imposed the discipline of working to the limits of a standard rectangle from the time I acquired my first piece of professional equipment. It also brought me physically closer to bees, birds, and people than I might have been behind other focal lengths, such as the telephoto.

Using a variety of lenses is enormously creative, but having lots of lenses can often be more distracting than useful. Spoiled by technology, it is too easy to forget that the camera obscura at first had no lens at all, and the early cameras but one glass element. A concentrated use of the standard lens without resorting to other lenses teaches expertise within average focal limits and normal spatial relationships. And when the picture maker later gets into other lenses, it's a more discernible change of perspective than if he had begun the education of vision with a camera bag full of toys.

When the mountain comes to Muhammad, it's a magical day indeed. The telephoto lens brings the viewer and the viewed closer to each other. This long lens collapses space, and therefore time. An automobile roaring toward the viewer seen through a telephoto seems to take forever to arrive, and the technique is used often in movies. A row of telephone poles seen lengthwise going down a road are sandwiched together, and distant peaks jump toward the eyes. A mountain is no longer hours off, but a glance away. If the telephoto lens is not of a fixed focal length (e.g., 135mm), but a telephoto-zoom, which may move from a range of 85mm to 205mm, it creates the cinematic excitement of moving through space as if by flying carpet to otherwise inaccessible places. Such a lens provides a choice of 121 different focal lengths, for seemingly infinite compositional possibilities.

Telephotos are useful for candid photography without disturbing the subjects, and with intimate portraiture they can get so close to the architecture of the face that results are often as powerful as billboard art, and sometimes just as flat. In landscapes or complex environments such as downtown locales, they distort normal perspectives, cramming geometry together, as with the telephone poles. Because they require a relatively high number of elements, telephotos rarely compare in optical resolving power with shorter lenses, and in the case of a telephoto-zoom, in which all the elements are changing relationships for the zoom capability, aberrations abound in all but the most recent products. Another burden of these "long eyes" is that the number of elements required for magnification considerably reduces the amount of light reaching the film, and therefore tripods and fast films are often needed. Their length also demands steadier hand-holding than other lenses so the front and back ends pivot as little as possible, since pivoting exaggerates the effects of parallax and causes blurring.

An answer to the various demands of this highly rewarding lens is to turn hand-holding the camera into a yoga of its own, lengthening exposure times to see how still you can be.

The wide-angle lens, usually of focal lengths from 21mm to 35mm, has enormous peripheral vision and depth of field, which minimizes the need for

critical focusing. But this lens, too, distorts geometry. As it distorts habits of seeing, it can become either a hassle or a creative plus for inventing perspectives. Its characteristic distortions are most apparent in attempts at architectural photography, where parallel lines tend to converge as in a fish-eye shot. The optics involved push things away from the viewer almost as though looking through the wrong end of a telescope. When photographing people, this effect requires closer involvement with subjects if the recorded images are to appear as more than tiny shapes. This lens is perfect for use in small areas and in crowds, and especially for getting candids of those who prefer not to be photographed. Its peripheral vision allows you to seem to point the camera off to the left and still get a picture of someone off to the right. Also, the exceptional depth of field attainable makes it possible to photograph a farmhouse some distance away and a much closer human figure, keeping both in relatively good focus, especially at smaller apertures.

Extraordinary use of wide-angle optics was made by Lennart Nilsson, the renowned Swedish photographer who has peered into the human womb and also into arteries. In 1969, he photographed the middle ear, which is barely the size of a sugar cube. With a specially made, tiny fish-eye lens mounted on the end of a thin hollow tube, he got an image that was projected onto a second, and larger, lens just one-half inch in diameter, which magnified the scene

twenty times before reaching the film. To get into that small cavity, he used flexible glass-fiber cords that bent the light into the space he wished to record.

The 7.5mm fish-eye is the most extreme of the wide-angle lenses, providing about 50 per cent more panoramic view than the eye itself, or a left-to-right scan of 180°. The results are spherical pictures that look as though taken into a mirrorized ball. Making fish-eye landscapes will bend the horizon into an expressionistic curve, reminding us as no other lens can of the planetary nature of Earth. It also places the viewer at the vanishing point in the center space within a bubble-shaped world!

The macro lens, commonly 50mm, is like a magnifying glass. It gives a fairly deep look into the often unseen and therefore unrealized worlds of insect jungles, the inner-spaces of soap bubbles with their special kind of momentary architecture, the tapestries of fungus, or the topical maps of human skin. Beyond ordinary lens demands, a simple attachment can hook the lensless camera-back directly onto a microscope. (See color section.)

Changing lenses causes major shifts in perception, running up and down the ratios of person-to-universe intimacy, altering sensory awareness almost as with Alice in Wonderland as she obeyed the signs that said EAT ME and DRINK ME.

# Photography as Sport

It is not unlike a Zen master to take his students to the edge of an awesome cliff and sit them along it, legs dangling in space, or lying down with their heads hanging over. Then, from this same posture, he will talk to them about life. Often, words aren't the least bit necessary.

An adventurous photographer finds himself climbing into precarious spots, being inundated by crowds, defying gravity, or having to become invisible in tense situations. Walking, flying, sailing, diving are exciting without a camera, but these activities undertaken with a camera can inspire you to stick your neck out a little farther. The widely published American Civil War pictures of Mathew Brady, taken mostly by a team of his assistants, are landmarks in war reportage. Shooting from the hip, getting "grab shots" from a speeding car or banking plane, shooting on a windy cliff to catch a seagull standing on an updraft, the eye reaches new heights of physical and spatial awareness.

Because photography centers consciousness in the eye, it is often easy to forget our bodies. In fact, using a telephoto lens on a cliff for a prolonged period can tend to separate the spirit from the body, as your eye seems to be "out there" in space near the wingtips of your quarry. Reaching out an extra few inches could provide frames for one hell of a photo essay on gravity!

Physiologists have demonstrated that the eye is less efficient when carried

passively (in a car, for example) than when movement is directly felt through the limbs contacting the earth. Some photographers start the day jogging or running with cameras in hand, making sure that they do not become merely eyes out of touch. They charge up their bodies with oxygen for that good feeling of bouncing along in rhythm on the earth. Feeling their lungs and muscles in fullness, they suddenly stop, focus on the first thing that catches their eyes, and start clicking away. With all their senses alive in high body awareness, they photograph from the psychological space of balance between body and spirit, rather than from the brittle detachment of armchair observers.

# Stillness and Change

Life is constant flux, from dancing molecules and wind in the trees, to the whirling of planets. Motion is perceived as things changing relationships, as figure and ground are clues for each other's movement. Parallax is the apparent movement of objects relative to one another, as seen when looking out the window of an automobile going through a moonlit night down a tree-lined country road. While the moon is racing neck and neck with the viewer, the far-off hills, the barns and silos in the middle distance, and the trees close up have different relative movements and directions. Parallax provides a sense of depth, even through just one eye.

Action photographs were almost unknown until the introduction of the stereoscopic camera (two eyes) in 1853. There were a few small daguerrotypes taken in 1841 of slow-moving traffic, and during the decade that followed, there were some pictures of trotting horses, walking men, and seascapes showing waves and steamships. Motion was recorded as a blur.

Fully five years before the announcement of photography, Sir Charles Wheatstone showed how a rapidly moving object could be frozen in perception by a split-second electric spark in a darkened room. Later, Henry Fox Talbot applied the technique that became the foundation for modern high-speed photography, which can now arrest the motion of nearly anything. In 1891, Lord Rayleigh photographed a bubble at the instant of

bursting, and in the early 1930s, multiple-flash photos analyzed the movements of tennis, golf, and other games.

In one of the most celebrated early motion studies, Leland Stanford commissioned Eadward Muybridge, in 1878, to record the leg action of a trotting horse, to settle the age-old argument of whether or not the "rocking-horse" position of galloping horses seen in paintings was valid. Using twenty-four cameras which went off in sequence in natural light, he exploded the myth.

With modern cameras and fast film, there is a broad range of options for capturing or expressing motion. A pole vaulter can be frozen in mid-air; through slower exposures or panning, a ballerina paints the air with brush strokes of light; and, through time exposures, stars articulate their paths on film. And, as in the Muybridge studies, a time-lapse series of pictures illustrates the progress of things, helping us read the volumes spoken purely in body language.

The geometry of composition can be used to imply motion where there may actually be none, such as when photographing railroad tracks. If the vanishing point is placed in the middle of the rectangle, it says one thing; but if the distant point of converging tracks is positioned neatly into a corner of

the picture, the lines of force suggest even swifter movement toward the horizon as the tracks "rush" away from view.

Movement expressed through a sweeping blur of energies, by freezing action in a crisp relief, or through geometry and composition, all conspire to move the eye into the picture, to feel around and exit with a sense of participation.

Part of the pleasure of a still photograph is that it waits for the viewer to read and feel it, and respond with his own personal rhythm. This makes prints or slides into oases of time in the midst of an otherwise frantic media environment, as the dominant medium of television forces us to speed up the pace of perception.

In the first days of Kodak's popular camera outfits, their advertising emphasized how easy it was to push their button; a hundred years later, in the 1970s, they dramatically emphasized the space-and-time-binding power of photography with "Hold a mountain in your hand . . . keep your baby a baby."

A cameraless celebration of movement is watching a tree in the wind and imagining that there is no wind at all, but that the tree is dancing of its own volition, its own joy.

There is a Buddhist story about the nature of movement, in which two monks walking along a path near a castle notice a flag above the parapets. One says, "The flag is moving." The other replies, "The wind is moving." The sixth patriarch happened to be passing and overheard the confusion. He told them, "Not the wind, not the flag; *your minds are moving*."

# The Selective Eye

"Whoever wants to see a brick must look at its pores, and must keep his eye close to it," wrote Ortega y Gasset. "But whoever wants to see a cathedral cannot see it as a brick. This demands a respect for distance."

Looking at something selectively magnifies it through *enlargement by attention*. Whatever is caught in the lens and strikes the eye virtually eliminates everything else in true "out of sight, out of mind" fashion. Allowing the camera to guide the eye as a divining rod of awareness is the more intuitive approach to making photographs. But the more critical approach is using the camera as a highly selective probe.

An exercise in eliminating some visual elements while selecting others can be performed using an empty slide mount. Using a 35mm plastic or cardboard mount, the rectangle can be brought near an object to delineate a texture or isolate a design structure. It can also be held at arm's length to frame a distant scene or nearer faces and parts of faces. Painters do this with their fingers forming the borders of view. This exercise brings home the function of cropping away all the world but a selected appearance, and is an easy method for introducing the art of seeing to children. And it burns no film.

But the eye doesn't want to get stuck in the frame. Too much framing can give rise to a sort of aesthetic claustrophobia. To liberate it from this

confinement so it can relate fully to the picture beyond the picture, take the eye out of the view finder and look again at the entire situation beyond the "tunnel" of selective attention. The photograph will be just a detail of the larger experience of shooting, with the eye and head free.

Yet, even as the conscious eye isolates a bordered space from the rest of the world, it is never really trapped by selective attention, because everything implies something greater. As Emerson expressed it: "Things are so strictly related, that according to the skill of the eye, from any one object the parts and properties of any other may be predicted. If we had eyes to see it, a bit of stone from the city wall would certify us of the necessity that man must exist, as readily as the city."

Not every photographer has the discipline or the desire to crop his pictures in the camera. It is much easier to do with a still life, and more difficult at the circus. Traditionally, unwanted parts of pictures are cut out in the darkroom with precise horizontal and vertical slices. But there are other options, such as using a circle-mask, which vignettes images in a way utterly distinct in impact from the hardness of the straight line. Early photographs, especially portraits, were often oval. The circle is a very satisfying shape in itself, suggesting unity, as in mandalas and magic circles used in Tibet and

elsewhere for meditation. The full moon appears round, as does the full Earth. Many other "perfect" natural forms are circles, such as the eyes.

The creative eye dances a line between drawing a bead on what it seeks, corralling or circling things "shot," and the intuitive surrender that allows images to magnetize and command attention.

# Seeking Cliches

Clichés are the basic visual and symbolic "types" that fill our lives. Clichés are born of archetypes, which themselves emerge from experienced truths. They are repetitions of human stereotypes. The variations are utterly infinite and infinitely subtle, but the basic themes between birth and death form the bass line for the human symphony.

Some universal clichés are The Fisherman, The Mother and Child, The Clown. Cultural clichés include The Hot Rodder, The Newspaper Vendor, Lovers at Coney Island.

The creative eye yearns for the "Now I've seen everything!" event. Yet it is the search for clichés that offers one of the most engrossing and rewarding areas of photographic study. Seeking an apple, that ultimate apple which could illustrate the word, idea, and experience of A for Apple in an alphabet book, is a discipline all too rare. It is all but lost to those visualizers who equate creativity only with originality. Clichés abound in the visual landscape. Finding and capturing an image of the all-time example of a Boy with Red Hair, Freckles, and Slingshot, brings with its hackneyed appearance and the feeling of "I've seen this a thousand times," a universality that photographs of unique subjects may not have.

Alfred Stieglitz, another American master of black-and-white photography, preferred this "exploration of the familiar," and would stand for hours

awaiting "the moment when everything is in balance." His contribution toward establishing photography as an authentic art during an active career of sixty years, beginning at the turn of the century, was tremendous.

People of advanced age often remark that, after a while, the world seems to repeat itself. They see the same things happen over and over again, but to different people, as "the same lovers" fall in love, the same nations go to war.

At the inception of *Life* magazine, in 1936, young photographers applying for staff positions or free-lance assignments were sent to Coney Island. If they returned with something really unique on that overexposed cultural cliché, yet with pictures really saying Coney Island, they were favorably considered.

If certain images or archetypes persist in my dreams or daydreams, I occasionally pick up my camera and set out to find, let's say, a white mare in a valley. If I find her, I photographically satisfy my mind's eye by photographing and meditating on this personal symbol until I have "worked it out" with this representative from my inner vision. Sometimes, wonderful, potent images are brought back from such a search. Other times, just the hunt itself is a full experience of light and the energy of curiosity. Really checking in on clichés can simplify one's outlook and enrich the realization that the universal contains the detail, and the detail represents the universal.

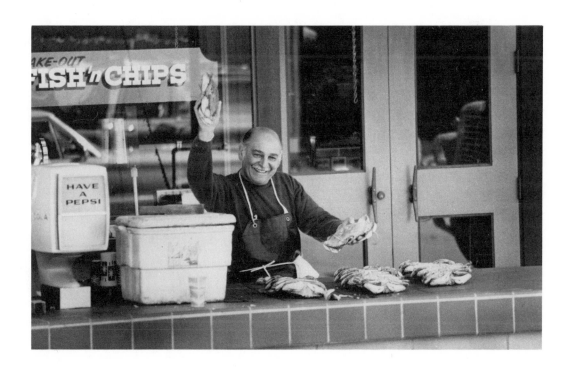

Finding a cliché and taking its picture is an experience of recognition coming straight from the heart (another cliché), and easily shared as a "word" in the visual vocabulary of recurring patterns of form and behavior.

A for Apple, B for Boy, C for Camera.

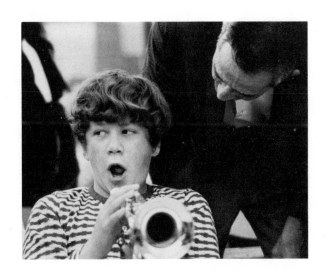

# Aesthetics

There was once a dispute between Greek and Chinese artists. Each claimed artistic superiority, so a great king put them to a test. He housed them in separate rooms across from one another, door facing door, and told them to create their finest possible work of art. The Chinese requested all manner of paints, while the Greeks asked for nothing but materials with which to remove any discolorations from the walls of their chamber. After some time, the king visited the artists' chambers. When the Chinese drew aside their curtain, the king beheld a picture so beautiful it robbed him of his wits. When he entered the Greeks' chamber, they opened their curtain, and the reflection of the Chinese painting on the polished wall was so incredibly radiant he lost his sight!

This old Persian tale is an interesting place to begin delving into the elusive question of aesthetics, which is usually reserved for the study and criticism of beauty.

Beauty has been carefully analyzed, and the results have been jealously preserved by such august governmental bodies as the French Academy, or by art schools, or by the Church, which for centuries proscribed certain subjects as not suitable for representation in the arts. Fortunately, such dogmas started to crumble before the turn of the twentieth century, when relativistic

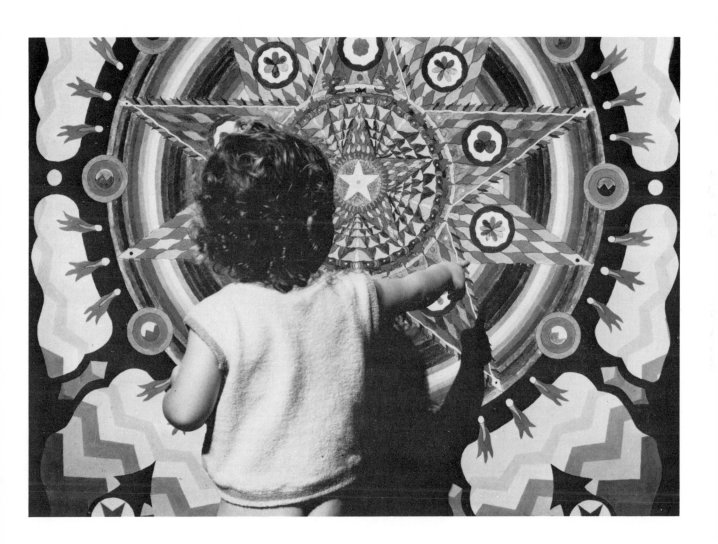

thinking began to dawn on Western Europe and America. Individual experiment and inner vision, under the threat of the Industrial Revolution, which was shaking up all known values, both sacred and profane, rose to the challenge. A historic break with the beauty monopolies held by official institutions occurred in Paris in 1863, when a small number of innovative painters were refused display at a major official exhibition. Their protest drew public attention, and they were given a hall of their own by Napoleon III. Their show, "The Salon of the Refused Ones," was a sensation, and is often identified as the birth of the *avant-garde*, the initiation of the revolution in modern art and perception. Among the exhibitors was Manet, whose *Le Déjeuner sur l'herbe* offended both the Emperor and the Empress.

Art action against the establishment escalated with the scandalous behavior of turn-of-the-century 'Pataphysics, itself a tiny manifestation and invention of Alfred Jarry; but the spark that ignited artistic rebellion to fever pitch was that of the Dadaists, thriving in the midst of the disintegration of the world during the great war of 1914–18, which later events caused to be dubbed World War I. One famous Dada caper was the display of an ordinary porcelain urinal offered as a sculpture titled *The Fountain*. Absurd, often terrifying juxtaposition of alien images was their basic technique for shocking complacent sensibilities into new awareness.

With the vigorous actions of the *avant-garde*, art began to move out of the salons of the rich and fashionable to the sidewalks of café society, as considerable attention shifted from museums to the ateliers of the artists themselves. Revolutions in art can also enshrine their tastes at each successive stage, but at least during the past fifty years beauty is no longer spelled with a capital B.

Before examining the aesthetic function, it should be mentioned that photography has had a rather bumpy career establishing itself as an authentic art form, partly because of its infinite diversity, and also because of its mechanical nature. To the common mind, photography merely reflects what is already there. Photography didn't gain a foothold *as art* until the early 1900s, and that was just a foothold. Debate still persists, revived now and then by critics who have certainly overdosed on images from television. Photography is not only an art in itself, but an integral part of other arts, from its use in New Realist painting to its integration with other art forms in "happenings."

The aesthetic function is that sensibility which says of a picture, "Yes, that hangs together." It is noticing the subtleties of line and form, of color or its absence, that come together in the service of new perception and insight. As it probes these interrelationships, aesthetics becomes the art and practice of

fascination, a balance of both analysis (concentrating on details) and synthesis (stepping back to experience the emotional whole).

Inhabiting individual skins, we always have in our aesthetic sense a mixed bag of visual biases and phobias explored in earlier chapters, and further illustrated by the appreciation some cultures have for artificially distended lips, while others (particularly the Chinese) admire naturally huge ear lobes, which resemble those of the Buddha and represent good luck. Some images attract or repel so strongly that attention is transfixed, and there is suddenly no longer enough emotional time to seek out the subtler aspects of the picture.

When pictorial art really connects with a viewer, it becomes a kind of Rorschach test, inviting conditioned or unconscious projections of meaning. Toulouse-Lautrec once exhibited a painting of a man in an overcoat and hat standing in a room with a half-dressed woman. A *grande dame* took one look and cried, "Obscenity! A woman undressing in front of a stranger!" Whereupon the artist replied, "*Ma-da-me*, the woman in my picture is not undressing, she is dressing, and the man is not a stranger, he is her husband. Obscenity is in the eye of the beholder, and I'll thank you to stop looking at my painting!" This may have more to do with morality than aesthetics, but the problem of individual bias seems well illustrated.

The word aesthetics was first used in 1750 by the German philosopher Alexander Baumgarten, implying *a science of sensuous knowledge* whose aim is the *experience* of beauty. This was meant to contrast with the science of logic, which seeks objective truth. Within the general study of aesthetics, some schools of thought stress the nature and varieties of form in art, giving special attention to historic types and styles, such as romanticism or surrealism. Besides these visual historians, there are those who are more interested in the psychology of creativity, of imagination and emotion. And another branch, known as experimental aesthetics, is concerned less with actual works or processes of art and more with discovering sensory preferences for a variety of arbitrary simplified lines, shapes, and color combinations, such as research on colors in children's playrooms.

It can be depressing to look at the environments that engulf modern populations, especially bearing in mind Baumgarten's meaning of aesthetics as the general study of sensory experience. We see most people caught up in artificial high-energy force fields of neon and fluorescent light, color television, traffic noise and its accompanying poisonous exhausts, the screaming of aircraft, and endless discomforts and distractions. This overload has accelerated the pace of life far beyond that of our grandparents. The widespread use of stimulants and tranquilizers may be an attempt to fiddle with the

dials on the inner time machine which we sense is going haywire. The intense involvement required of city dwellers, which most people are, has short-circuited the slower, natural bio-rhythms, creating a race of visual speed-readers who apply this frantic energy to speed-reading most experiences as attention races beyond conscious control.

It is true enough that the electronic information environment has created greater knowledge of one another among the disparate peoples of the world, melding the multiplicity of states and nations into a developing global village. But what is too easily overlooked is the fact that the global village is also a company town.

Contemplative aesthetic awareness, therefore, is not merely a creative pastime for the sensitive lover of beauty, but a return to the soul-making birthright which has been brutally distracted by the technology that serves the provisional interests of a social economy rather than the inner longings of the spirit. The aesthetic process is, more than ever, a survival tactic.

I vividly recall a sailing trip on San Francisco Bay a few years ago, aboard a thirty-two-foot Bermuda-rigged sloop, with another passenger and two crew. As the afternoon blew on, the ballast broke loose in the hold and heavy winds dumped us on our starboard side. The crew was loud and clear that we could only wait it out. All aboard wore life jackets, but our passenger

clung frantically to the mast yelling, "Do something! For Godsake, *do something!*" Clinging to the cabin roof, I suggested to our stricken friend that he take a look at the "sky-blue sky" and pause over the glistening reflections bouncing off the green water. As the weather passed without injuring anyone, and we righted, he couldn't find enough purple language to describe my focusing on the visual beauty surrounding the incident. My only excuse was the habit of seeing photographically, and the belief that sometimes responding aesthetically is *also doing something.*

# Land, Sea, and Cityscapes

In the Western world, mountains had been regarded mostly as inconvenient or dangerous obstacles to travel, or as natural barriers against attack; that is, until 1739, when the poet Thomas Gray wrote in a letter about his visit to the Grande Chartreuse: "Not a precipice, not a torrent, not a cliff, but is pregnant with religion and poetry." Landscape photography lends itself beautifully to the contemplative experience, as exploring the natural surfaces of the earth can heal the eye and warm the heart. A photographic vacation of even a few timeless hours can seem like a fulfillment of many days.

Seeing the land from the normal elevation of standing up is the most common angle at which photographs are made. Yet, crawling through the grasses, smelling the earth exhale its perfumes of miniature jungles and unseen worlds, brings the sense of adventure equaled by Alice plunging down the rabbit hole. This ground-level approach produces coyote-eye views of natural surroundings, and with a macro lens you can experience the "aerial views" of a mosquito.

Just as there is visual music, so are there visual echoes. In the worlds of nature, the larger structures and forms often echo the smaller patterns and textures. Clouds bank against a mountain and physically echo the shape of its ridges. The bark of a tree ripples almost exactly as the water in the stream at its feet.

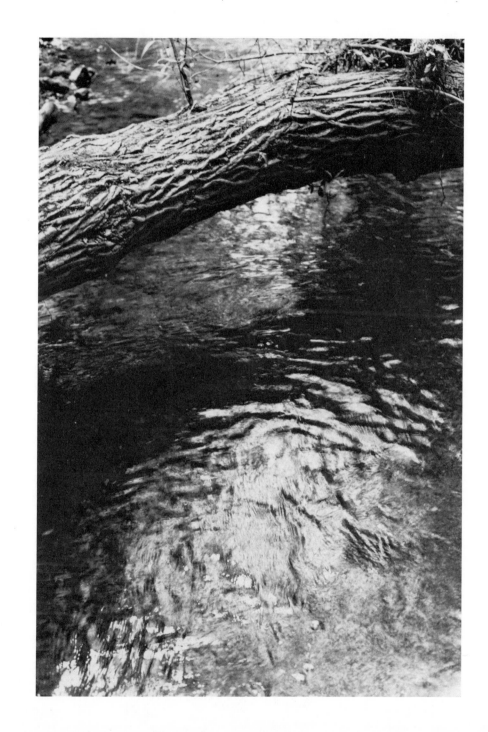

The ocean, taking up vastly more planet surface than the land, is a frontier of such mystery that the undersea explorer Cousteau calls the realm "inner space." It is dazzling to stand in the midst of a flock of birds rising madly about you off a field, but you are still earthbound, clicking away in the flutter. But, undersea, you can be *in* a cloud of fishes, turning this way and that in a choreography of dancing light-patterns—and you are swimming too! A hazard reported by divers, in such spaces where they so completely identify with the forms and images around them through some hypnotic memory of our evolutionary origins, is that they sometimes forget they are human, and separate from their breathing apparatus to join the school.

Rising above ourselves for an overview of the human condition was first experienced by Pilâtre de Rozier and the Marquis d'Arlandes, who, in 1783, rose above Paris in a hot-air balloon. The French caricaturist-turned-photographer Nadar took the first photographs from an aerial vantage point over Paris in 1858. He also made the first underground photographs of the catacombs and sewers of that city. The opportunity to rise out of the limited self to see a holistic view of land-, sea-, and cityscapes allows the individual an exhilarating recognition that he is a part of something vaster than daily experience suggests. The immense cloudscapes are a continuous circus of living sculpture seen from the ground. From above, in a balloon, sailplane, or hang-glider,

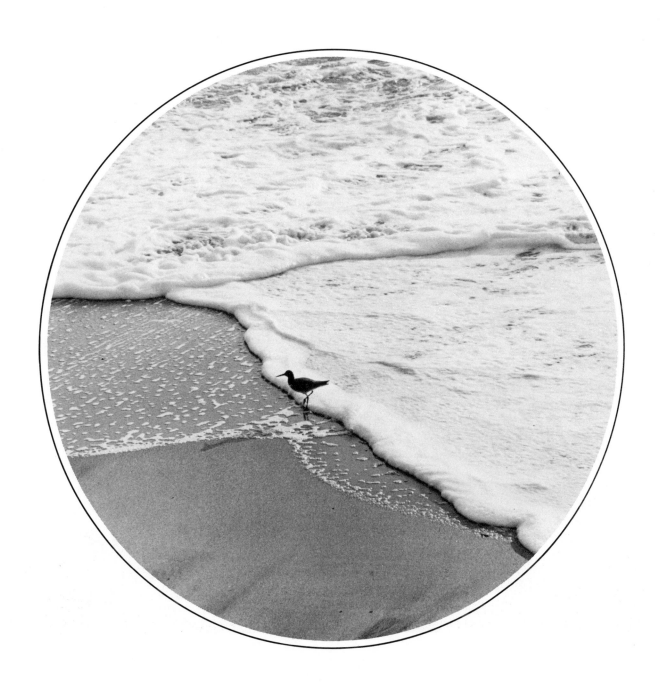

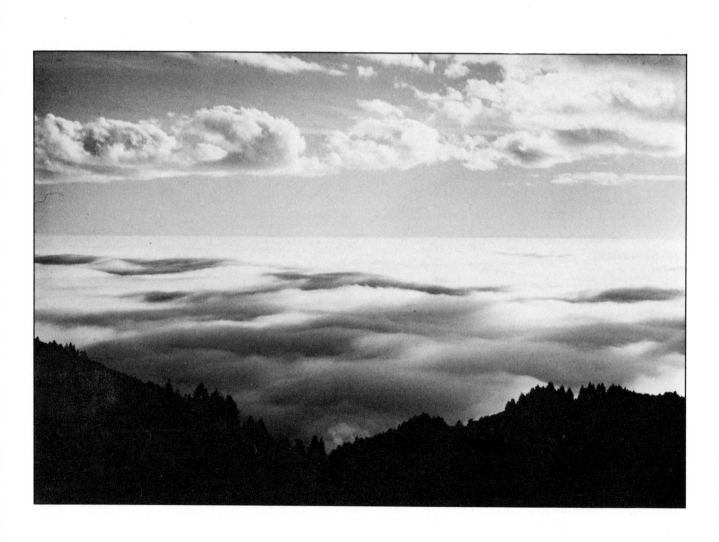

the photographer joins the circus of changing forms and apparitions of nature at play.

Looking down to see your home town is an unforgettable moment of aesthetic distance. Approaching the landing field, everything appears to grow larger and larger, until you have returned to accustomed spatial relationships.

The urban environment is the habitat for most of mankind, and for a majority of Americans. Although every major city in the United States suffers from decay and crowding, only 3 per cent of our land area is built on. Why governments encourage high-density "huddling of the masses" cannot be dealt with here, but an examination of any urban scene is rich in sorrowful evidence of what such policies produce. Walking or driving down the streets of neighborhoods or commercial districts, clicking each house and shop front for a few blocks, getting a slice of life for every address, accumulates the elements for a unique project. Once the pictures are developed and printed, they can be cut out like paper dolls and spliced together in a miniature panorama of the human condition in cityscapes. Erected like a model-train town or the cutouts that once came on the backs of cereal boxes, an overview is achieved, yet an intimate one, as though the photographer were a sympathetic Martian anthropologist.

When the photographic eye is used for the planetary perspectives of over-

view and environmental picture making, and the photographer has wondered at creation in the womb of oceans and drunk in the sights of valleys and open plains, he cannot help but ask imponderable questions about the nature and origin of what we have been given and what we are doing with it. And these questions are answered visually, silently, by the probing eye itself, as once expressed by a student of mysteries:

"When I knew nothing, mountains were just mountains and trees just trees. When I learned more, mountains became much more than mountains and trees more than trees. Now that I have attained realization, mountains are just mountains again, and trees are trees."

# Animals

Photographing animals is one of the high adventures of seeing. It satisfies quite a range, from the natural, primeval hunting instinct to the poetry of aesthetics and the need for meditation. Who can forget Blake's recognition of that "fearful symmetry" in a tiger?

There is a personal and artistic distinction between photographing creatures at a distance with a telephoto lens, and photographing at the closest critical distance you can either secretly achieve or, better yet, work out with the subjects themselves, using a standard lens. In the case of insects, the macro lens is inevitable. Animal and insect species have particular differences in the critical distance they allow between themselves and others. A prairie dog would not come closer than a few yards from a coyote. So the question arises: in photographing the many-footed ones, are we merely spying on our fur-covered brothers, or relating *with* them? Spying is appropriate if they are known to eat cameras, or in order to leave nesting creatures undisturbed. But whistling up a deer, or staring with an owl in the early morning, can change your own vibrations by letting the light shine in as it flows from the eyes of those non-human beings who never complain. Once you see a deer moving through your field of vision, whistling a *long*, smooth note will often stop him, and he may stand there with ears cocked as long as there is something to fascinate him.

Animal photography reveals how much calm centering is required to ap-

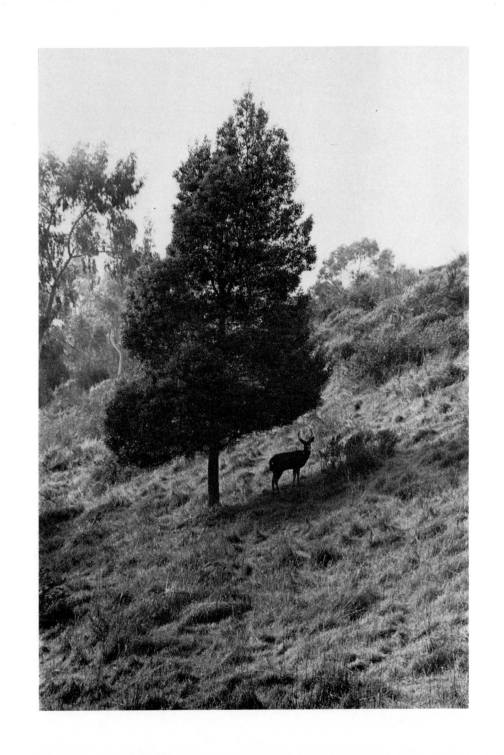

proach "wild" animals without scaring them or yourself away. Using body language to communicate with a four-foot encountered along the way develops a dialogue you may not wish to interrupt even for the click of a shutter.

There are ways to bridge the language gap with many other creatures. Besides the deer-whistle connection, there are things that can be done with tent worms. Tent worms look like caterpillars and build nests that look like tents and are greenhouses for larvae. One spring I saw some on the plum tree in my garden. Moving very close to them, I took a couple of pictures, but there wasn't much action. Joking, I said loudly, "Dance!" and to my astonishment they all raised their fuzzy heads and danced! For a while, I visited daily, and whenever the sound of a voice tickled them they stopped pitching tents and danced. Of course, it may all have been the result of a hot and alien breath.

Photographing domestic animals, who are always somewhat animal and somewhat human, is a different matter. We know how human-like pets become after a few months of living with a household. Examples of dogs who look strangely like their masters in face or stature can be seen in any city park. It would be interesting to explore photographically just how dog- or catlike people become after being shadowed in daily life by an animal alter ego.

Pet pictures can be casual and candid, but it's more fun to get Rags to lick

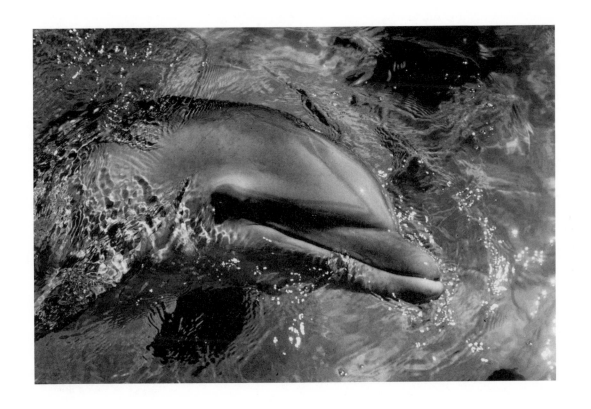

his chops or catch a Frisbee for a portrait. So with my own shaggy beast I said, "Do you want some foood?" He *slurps* and I *click!* Even without games, there are cats and dogs who seem quite aware of what posing is. Do they really posture for us, or do people project a stylization upon whatever position they strike?

Pet animals invariably show cuteness and corruptibility, and so have little to teach us, being members of the human circus. It is the remaining survivors in wild habitats who have something to say, as John Lilly found during years of living with dolphins, exploring far reaches of communication with a non-human intelligence.

Making animal, bird, and insect pictures through achieving a real understanding with them reveals to the photographer the enormous difference between the vibrations he puts out when feeling separate from his subject, and when he feels unity. The richness of encountering the fauna of planet Earth turns most on the real sense of friendship brought to the moment when the photographer meets a deer in the forest or an ant on his shoe.

# Color

Color! The very word excites imagination and focuses consciousness in the eyes. It adds to visible forms a mysterious clothing of emotional tones and symbolic meanings. Color is reality, as black and white is abstraction.

There is only a modest amount of scientific knowledge about color phenomena, and considerable philosophical disagreement on the subject.

There are two types of light-reading cells in the eye: rods and cones, named for their appearance under a microscope. Rods see mostly light-contrast. It is the seven million cones in each retina that sense both light and color, although there is evidence that for blue day-vision, these get some assistance from the rods; and, similarly, the rods get assistance from the cones.

The three primary colors, red, yellow, and blue, are those which cannot be produced by mixing other colors. Complementary colors are those which, when combined, reflect as white. The color transmitted is always said to be complementary to the one reflected. Accidental colors are those seen on a white surface after looking at a bright object, such as the sun. The accidental color of red is bluish green; of orange, dark blue; of violet, yellow. And vice versa.

The human eye discriminates a hundred distinct colors, and if all mixtures are taken into account, a thousand or more. Yet the color phenomenon is so elusive compared to that of form perception, that in experiments with

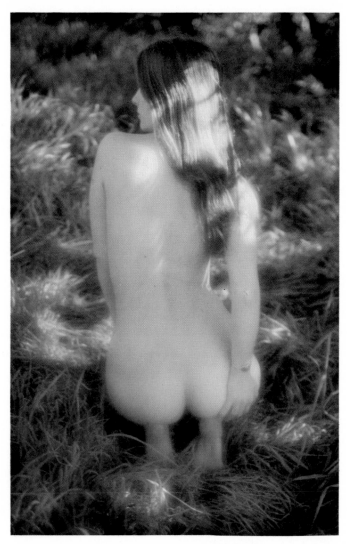

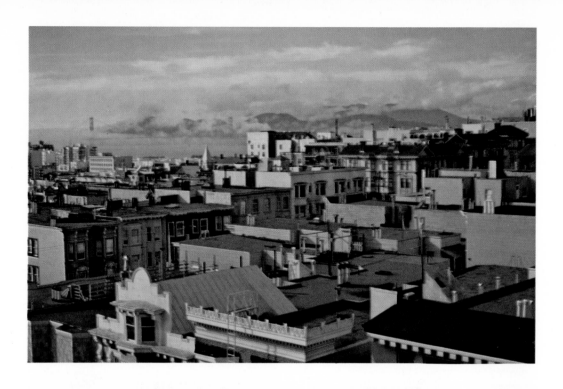

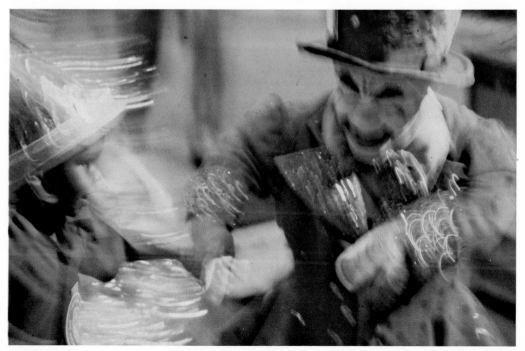

people who were shown twenty-five different *shapes* in one sitting, and shown a group of shapes sometime later (which included many of the first group of shapes, with some new forms added), subjects easily recognized the familiar ones and easily spotted the new ones. Not so with *colors*. Apparently, our color memory does not function with anything near the accuracy of form memory.

Cultural groups have some particularly convenient methods for remembering certain colors, through ethnic and religious traditions, as color has been used for decoration since prehistoric times.

The ancient Greeks, as we know from their plays and temples, reserved gold and purple for royalty, and red for heroes. Black, from time immemorial in the West, indicates grief. Yellow, in the Western traditions, has been a generally despised color, signifying heathens, cowards. In th Orient, however, yellow is associated with Buddha and Confucius. A greenhorn for us is a dolt fresh from the country; for Moslems, green is the holiest of colors.

Displaying the white feather or a white flag, a symbol of surrender and peace, is supposed to inspire mercy in those who see it. White surfaces reflect all colors, and white light in many religions is seen as the ultimate ray of divine source.

Black absorbs all colors. We go to funerals in black, but in China we must go in white.

This tiny sampling of color lore touches only a few of the complex uses to which mankind has put its exquisite visual sensibilities. The order of color preference among Western cultures has been generally consistent: blue, red, green, purple, orange, and yellow.

Psychologists regard the color sense almost as an equation for emotional aliveness. It is unusual for a person physically capable of seeing color to be emotionally blind to it, but there are many degrees of physical color blindness. Men are ten to twenty times more subject to this inherited characteristic than women. Happily, a completely color-blind person is exceedingly rare. It has been widely reported that people with highly emotional or neurotic dispositions have rather characteristic reactions to certain colors. Some neurotic individuals experience "color shock," and are very slow or unable to respond to color tests. When they do react to partly colored Rorschach ink-blot tests, they often identify the colored parts as sunsets or as blood.

Color also has purely physical effects on the nervous system, demonstrated by the fact that blues pacify babies and reds create muscular tension in test subjects. A recent, three-year study in Germany revealed a pronounced difference in IQ and learning ability between random samples of 473 children

when one group was put in playrooms that were painted light blue, yellow, yellow-green, or orange—which were colors the children said were beautiful —and another group in rooms painted with "ugly" colors: white, black, or brown. Researchers found that the popular colors stimulated alertness and creativity, while the white, black, and brown playrooms actually made the children duller. Those surrounded by orange walls and orange playthings reacted most positively toward each other, with increases of friendly words and smiles.

In other tests, in other times and places, blood pressure increased in adult test subjects under red light and decreased under blue. Heart rate, however, was not apparently affected. Respiratory movements increased under red, decreased under blue; and frequency of eye blinks increased with red and slowed with blue light.

Many other creatures do not share the color experience with us. It is almost certain that no mammals below primates see color. Color perception is highly developed, however, in birds, fish, reptiles, and insects such as bees and dragonflies. A dog sees black and white and shades of gray. Bony fishes, parrots, lizards, crabs, and turtles see color. Cats and rats do not.

From the beginning of photographic history, critics were disappointed that nature's rainbow was not registered in pictures. The stir toward modern

color photography occurred during the first twenty years of this century, but a practical process was not available until the appearance of Kodachrome, in 1935, although there were rare examples of complicated, expensive color photos as early as 1861.

In making color photographs, it is easy to be sucked into the color itself, to utter distraction, nearly blinding the eye to the subject and form at hand. If not under conscious control, color can become a parasite on form, wrapping itself around an object, devouring it. An exercise in the delicate balance of color and form is using color film in essentially black/white/beige/gray situations, or in places where there is color, but just a little, which attracts attention without arresting it. Fog, as described in the scene at the edge of the horse ranch, helps mute colors wherever they creep in.

Yet no matter how much color is under control in the camera, there is nothing so head-on erotic, in the sense understood by painters, as allowing color to overwhelm the receiving eye. Photographs of peeling paint or close-ups of torn sections on a billboard are common fare at photo exhibits. Color for color's sake, letting it take over to the point of becoming the whole message of a picture, produces powerful effects. Through panning or jiggling the camera, colors mix and dance as though on a painter's palate, liberating the eye and body from the relative stresses of framing, composition,

and focus. For the viewer, such experiences of pure design and energy can be a sensuous relief from photos loaded with meaningful shapes and symbols.

Various color films are more sensitive to some colors than to others, creating a gap between the color experienced and the color recorded. Anscochrome, for example, is more sensitive to the purple range, while Fujichrome is more responsive to greens and pinks. And you must also take into account your own degree of color bias or even partial color blindness.

Not only does each film brand have its own coloration weights, but it is also interesting to find that they can all record more than the eye can see. I remember standing in a pitch-black night near the San Andreas fault pointing my camera at the constellation Orion. I saw nothing but white stars in a black sky. It was the kind of night when the sky appeared as black velvet, and instead of stars you could believe for a moment that light was poking through worn-out spots of the fabric, coming from the fires of a neighboring universe. I set up my tripod and photographed a chunk of sky with a 55mm lens at an exposure of about four seconds using Fujichrome (ASA 100). When the slides came back from the lab, there was Orion all right, with the jewels of his sword sparkling not only in white light, but some in red and green; and the sky showed not black but deep turquoise. And there were clouds, just little ones, which had been invisible to my naked eye at the time of exposure.

Night photography always reminds me of a banner that appeared for some years on the cover of *The American Cinematographer:* GIVE US A PLACE TO STAND AND WE WILL FILM THE UNIVERSE. That was in the twenties. In the twinkling of an eye, we had photographs of the lunar landscape with the earthrise in the background.

The Earth was first described from space as a blue marble.

# A Still Life Is Still Life

The creative encounter between artist and still life is realized in what Edward Weston describes as "The photographer's power . . . to re-create his subject . . . in such a form that the spectator feels he is seeing not just a symbol for the object, but the thing itself revealed for the first time."

The editors of *The Art of Photography*, part of the Time-Life Library of Photography, gave eight professional photographers an experimental project for that volume: "Your assignment is to take this mannequin and, using it in a situation, make a photograph that will satisfy you creatively and communicate your reactions to the viewer." The same antique wooden dummy was used by each photographer in succession, and the pictures that resulted ranged from a macabre shot of the dummy in a blood-spotted shroud, to the mannequin seated cross-legged with a bouquet on its lap. Likewise, the individual photographer can use a single object and devise a variety of setups to explore its possible moods as it is moved into different surroundings. Such deliberate manipulation of objects lends itself easily to the creation of illustrations, and editorial communication such as poster art.

Setting up a still-life composition is one thing, and letting "the gazing eye fall through the world" is another. Wrapping the rectangular frame around a just-found object or grouping stylizes random structures, which can give them a "set up" feeling. Just as the realm of nature expresses its cycles in sea-

sons, objects rest in the atmosphere of their own moments, a kind of season too. The eye can return to photograph the same staircase rising to nowhere, or a discarded toy, and make pictures of it every few weeks throughout the year. It may change from weather and time. If it has disappeared, there is suddenly the opportunity to photograph something that is conspicuous by its absence! Thoreau wondered, "Why do precisely these objects which we behold make a world?"

There are objects of our affection, those which go unnoticed, and some we find repellent. What begins as affection can mushroom into a collecting mania. Creative affection can become the pursuit of symbols such as windows or seashells. The photographic medium permits the avid hunter to collect something while leaving it where it is found. A service to those who can go bananas for the love of seeing certain things is *The International Image Exchange Directory*, issued from Vancouver, B.C., Canada. Artists from all over the world send their names and addresses along with a short list of what they would like others to send them. One listing asks for "pics of people blowing smoke-rings." Others request pictures of abandoned staircases, decals, roadside diners, kids fishing, automobile graveyards, warts, flowers.

Some of the most interesting still lifes are those which are the leftovers of human activity, which by their positions imply the ghostly hands of a past

drama, such as a single shoe found by the roadside, a kite hanging from a tree, or the inevitable inside-out umbrella. Henry James captured in a poem the way furniture echoes activity:

> "The displaced chairs,
>     At awkward angles to each other
>     Seem to retain the attitudes of bored talkers."

# The Click That Kills

When making a picture, the sound of the shutter can "click off" the scene. One immediately turns to look for the next thing to shoot. To avoid killing what you behold, *linger* on it. Not merely saving the view for posterity, but *savoring* it in the now is the only antidote to this subtle occupational hazard. Most situations, except in the practice of hot-news photography or in recording other unusually high-speed events, can be seen and felt at a graceful pace.

As the environment pulses with events both minute and sweeping, lingering on the continuity and flow is important to the art of catching meaningful moments out of time. Stopping the world in 1/500 of a second must not merely embalm peak moments, but rather make their flow more alive to the viewer, more "real." The human eye itself "clicks" at a rate equivalent to ten frames per second. From the photographic standpoint, life is not unlike a vast movie out of which the discriminating eye pulls significant frames. The thirsting eye can drink from the rivers of light, yet still let them flow.

Since the dimmest days of prehistory, our hunting instincts have slowly evolved from the slaughter of animals toward farming, and onward to hunting information through both intellectual research and visual exploration. We still "go after" a picture, "shoot" a subject, and "capture" expressions. But, as with the naturalist, it is far more satisfying to use the camera as a tranquilizing dart on the wild things of perception, rather than letting its click be a kill.

# Do You Want Me to Smile?

Snap shooting became a public pastime for hundreds of thousands of amateurs in the 1850s, who took pictures mostly of family and friends. Portrait studios flourished, and portrait calling cards were the rage. These early portraits make our ancestors look like a bunch of stiff-necks. Victorians *were* Victorians, but to be fair it must be remembered that a portrait session usually required long exposures, and the studios were outfitted with chairs and head braces similar to those used by dentists. So our upright progenitors must have been looser than they appear in the huge number of extant photographs sold in junk shops or found in attic trunks.

With fast modern films and lenses, it is a simple matter to capture the animated expressions of facial features working together to reveal moods and attitudes, communicating intended messages and still other signals that just "slip out." In studying faces, it is sometimes helpful to block a subject's eyes with your hand from a distance and just watch the mouth, or vice versa. Or cover the left side to concentrate on the right, as the two are always different, one being happier or older than the other. This technique proved fascinating while watching televised Senate hearings, as a witness would say one thing with his mouth while his eyes were contradicting it.

There is no aid to seeing quite like closing the eyes. Before photographing a tree, feeling it "in the dark" reveals so much about its structure and vitality,

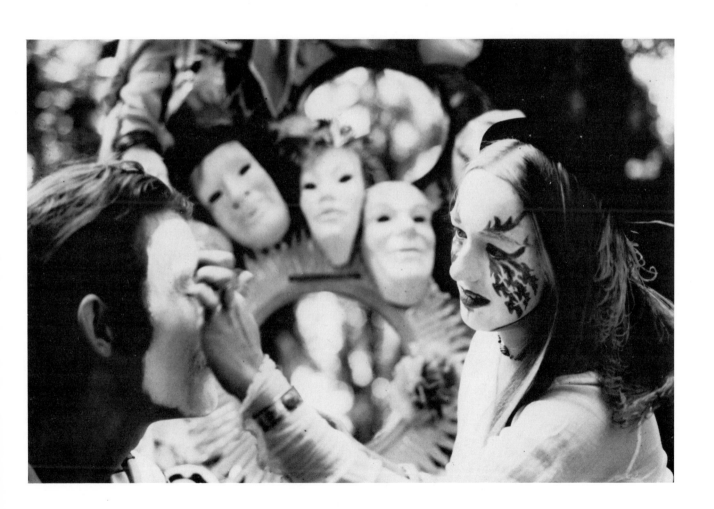

its *thereness*. In making a portrait, feeling the face as a sculptor enriches the understanding of living features. The fingers receive that which can hardly be described by words or seen with eyes. With eyes open, the photographer's mind stops where his eyes stop, in linear space. But, seeing through the fingertips, he is plunged into the infinity of acoustic space as they X-ray the bony architecture of the mortal form. Of course, it is best to know the subject personally in the first place, and discuss this rather unusual approach beforehand. But portraitists have done stranger things than this.

Yousuf Karsh exercises total control over his sitters, most of whom are eminent figures. When Winston Churchill refused to remove from his mouth that cigar which was his trademark, Karsh simply plucked the offending stogie from the Prime Minister's lips! The resulting picture is generally regarded as the greatest contemporary portrait in the classic tradition.

Robert Frank, on the other hand, wasn't interested in control, or in the "decisive moment," but, rather, random points in time. His pictures portray faces unself-conscious and off guard. He went into the streets and parks almost as a voyeur or fair witness. His 1959 publication *The Americans* showed a nation of everyday life, capturing the "in between moments" of ordinary people. His work seems like a collection of deeply felt snapshots.

Being recorded by a camera has always been somehow more threatening

than being seen by eyes alone. It is believed by some tribal peoples that a photograph steals a part of the subject's soul. Others just don't want to be "caught in the act" of living. So the gentle art of portraiture requires a photographer whose approach assures his subject that he is seeking the light of personality and living character. A portrait is never made in a vacuum, and the interaction between the seer and the seen will either evoke or distort inner moods and outer expressions as the photographer does his "photographer's dance." If he is too intense, many a flower of personality will wither under the seemingly omnipotent gaze of the lens.

"If the nose of Cleopatra had been shorter, the whole face of the world would have turned out differently," observed Pascal. Making pictures of people is a delicate matter of working with the fragile elements of privacy, self-consciousness, and vanity.

> "There will be a time, there will be time
> To prepare a face to meet the faces that you meet."

No normal person is entirely free of this sentiment expressed in T. S. Eliot's *The Love Song of J. Alfred Prufrock*. The word vanity derives from the Latin *vanus*, meaning empty, void. When photographing women, the repertoire of masks of beauty every little girl is taught comes peeking through,

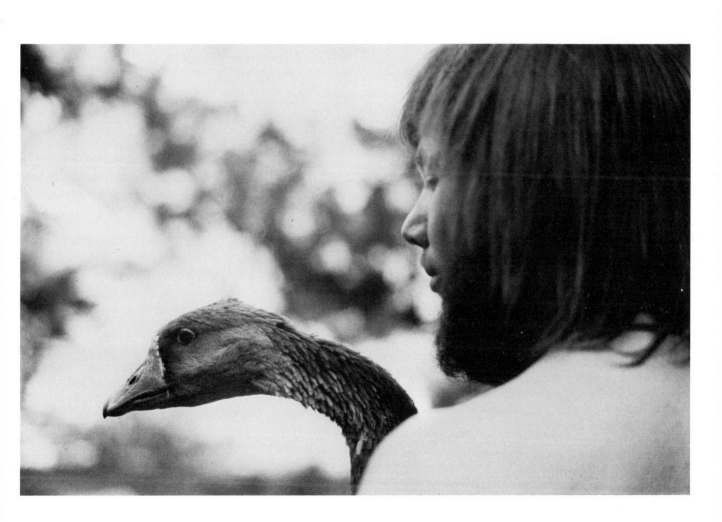

echoing past games of personal magnetism and promises of future incarnations. If her inner image and outer appearance are in relative harmony, it radiates through the language of her features. Clothing styles and the cultural consensus of beauty change like the weather, rendering glamour perishable. But grace of carriage (not necessarily feminine grace, but the unmistakable quality of easy movement shared by both sexes) and inner glow transcend timely taste, revealing that *beauty is a verb*. Human beauty shines in the portrait as the best available light.

As soon as the camera turns toward men, the myth that only women live in the mists of vanity is exploded. There ought to be a distinction made, however, between vanity and simple self-awareness, as men have much less active experience in the art of being "good-looking" in the current century. Fashion history shows that women have had the luxury of experimenting with their self-images, often to please men, while men have been dressing like morticians, in subdued colors, largely to please their employers. It is this inexperience in creative self-expression that can make the male portrait subject uncomfortable once the lens turns in his direction.

Portraits are best done in the sitter's own environment, or in a favorite natural spot. Such environmental portraits feel more natural because the subject is not spending the energy of his personality settling into a strange

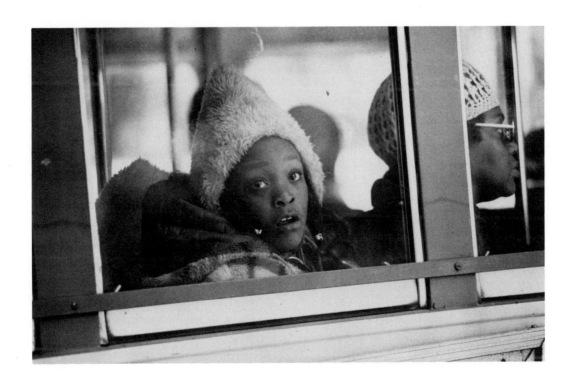

space, such as a portrait studio. The portrait of a man at his own workbench or on his sailboat will be as different from the studio piece as a picture of an animal in the African veldt is distinct from zoo pictures.

Old people are more sensitive about being photographed than anyone else, a likely result of the "youth cult" marketing tactics employed so mercilessly by advertisers of everything from make-up to tonics, all of which amounts to a lifelong barrage of propaganda telling people they cannot possibly be a joy to behold if not "youthful." It may well be, however, that a camera in the hands of an older photographer is more welcome than in the hands of an eager young one. And between the sexes there is a double standard of aging, which has supposed that a man who ages develops "character" in his face but a woman just gets more wrinkles. This is slowly changing, as the coming generations are more and more interested in the essence of communication and less in image. Even as the fatigue of living sets in, as life-spans lengthen, long experience need not destroy beauty, but change it. What more inspiring subjects exist than those whose great age has given their eyes the light of understanding? Or the twinkle of amusement in a grandparent's eye? Or the penetrating gaze of an elder master in the arts, whose long view has developed out of years of rooting deeply into the labyrinth of creative vision? Every

study of the human face is a restatement of what life is about, and a smile is a smile in New Guinea or New Heaven.

Photographing children, the aged of the future, is more pure fun than any other kind of photography. Contained within every child is an animal spirit ("What animal would you like to be?"), an adult hero, and the growing child himself, rushing through changes. We are all many people inside, carrying within ourselves parents, teachers, brothers, sisters, and pet animals. A little rubs off, or we would be unresponsive and immune to the touching we receive. And in the child, more than others, is the person he wishes to become. It was once observed of adults that within every fat man a thin man is gesturing frantically to be let out!

Just as with adults and animals, it helps to let kids feel you as a friend and playmate. One connection I use is to give young subjects a good look at me through the camera, or with a toy camera. I often ask young people coordinated enough to handle a relatively hefty camera to take my portrait first, which evens up our roles a bit, and also provides some delightful interpretations of the photographer's face. Often it will be the first photograph the child has ever made, and, when he sees a print, it may infect him with photomania, and the desire to use the eyes creatively.

Because children are the world's greatest hams, photos of their freest expressions rarely come while posing or in portrait sessions, but rather when they are really unaware of the camera. Not that they don't "mug" with each other, but scenes caught with a telephoto in their world differ greatly from those which occur when they pretend to be children in ours. It is so much richer to photograph the changes a child goes through when playing alone or with his peers, as he moves through the roles of other people, animals, and spirits. A haiku by Issa:

> "The children imitating the cormorants
> are more wonderful
> than the real cormorants."

While interpreting the personal joys and struggles articulated in the bodies and reflecting from the faces of others, moments come when the photographer catches his own image in a shopwindow or the mirror on a weight-and-fortune machine. In a sense, all photographs are self-portraits. But if you think you are a subject too difficult to interpret, there is always a three-for-fifty-cents photo booth lurking near the pinball machines at every bus station throughout the known universe.

What a surprise to discover a face of your own!

# Nudes

Plant life, clouds, the birds and beasts of the earth, all have one thing in common: They are nude. People, however, have been covering up for a long time. In some cultures, even faces are veiled.

Mention nude photography, and the first thing that comes to mind is naked young women. This is probably because all the inventors of photographic processes and most photographers have been men. As cultural evolution advances, more and more women are using photography for self-expression and we are beginning to see more serious nude photography of men.

Whether the approach to this art of capturing the primeval essence of people is frankly sexual, or more general and sensual, a nude photograph moves an individual beyond his or her place in time, revealing a common humanity. Yet, no matter how design-oriented the study might be, the nude can never be wholly separated from sexuality. Seeing the unveiled form has been likened by poets and photographers to an act of love. Giving someone the eye often results in giving the heart.

Until recently, Western culture has behaved as though men were gross bodies and women celestial beings. The repressed, hypocritical Victorians immediately come to mind. As the tremendous national growth in human potential workshops has shown, people are just beginning to learn how to live happily in their bodies. It is just possible that the historical use of cameras

to study the nude woman has not merely reduced women to objects (à la *Playboy*) but, in the healthier sense, has served to *embody* the previously disembodied female.

Wherever the nude study goes, celebrating the display of human lines and fleshly forms is full of surprises for people with cameras. Adventuring into a secret meadow or gamboling on a free beach, a good way to share the journey is to be sure the photographer isn't behind his clothing just looking out. Some historians allege that Lady Godiva's celebrated streak through town on a white horse prompted awe-struck villagers to hide their eyes as she passed except for one chap whose name was Tom, who peeped! Raising the nude study beyond voyeurism, keeping a human focus on the models, the photographer can always remove his or her clothes too.

Nudes can be "clothed" by projecting images of other forms onto skin during the session. These living tattoos let you body-paint with light, coloring the body with the geometrics of technology, natural forms such as rippling surf; or the human form can be decorated with features from animals, creating a legendary chimera.

The way bodies move speaks volumes about the way their spirits feel. Some move like fawns, others like robots. As nudists know so well, without the clothing and baggage of ceremonial costumes dictated by class and

culture, there is much more room for the essential character to shine through. The costumed personality is in some ways easier to "see through" than the nude being who has nothing to hide.

The art and experience that emerge from nude photography depend, of course, on the attitudes of the seer and the seen. Ikkyu noted that

"As for the skin, what a difference between a man and a woman!
But as for the bones, both are simply human beings."

Nude studies can easily serve the needs of sexists. But they can just as easily be a special sharing space among those who love the body as the temple of the soul.

# Did You Do That on Purpose?

Artists and craftsmen want their tools under control. Yet, with an appreciation of accidental image making, stumbling onto new techniques helps define the growing edge of the photographic experience.

A photograph that is unintentionally blurred, or clearly out of focus, can be used in myriad ways. If it is a black-and-white print, it can be hand-colored with marking pens or watercolors, becoming a tapestry of energetic zones, a mosaic of beyond-the-real colors. If it is a color slide, it can be enjoyed as is, or a variety of widely available texture screens can be sandwiched on top of it. Such an added texture, which may look like canvas or cracking paint, will often reintegrate the structures of the blurred image, providing impressionistic detail. The art of the photographic sandwich will be explored later.

Seeing the surround as a collage of soft edges can broadly enhance an individual's world view. An example of such a mentality is R. Buckminster Fuller, inventor of the geodesic dome (among other technical breakthroughs), and father of World Design Science, the holistic study of interacting systems.

Fuller reports that during the first four years of his life, his eyesight was so fuzzy that all he saw were large patterns. Faces were oval areas that spoke, houses were rectangular things with holes for walking in and out, and so forth.

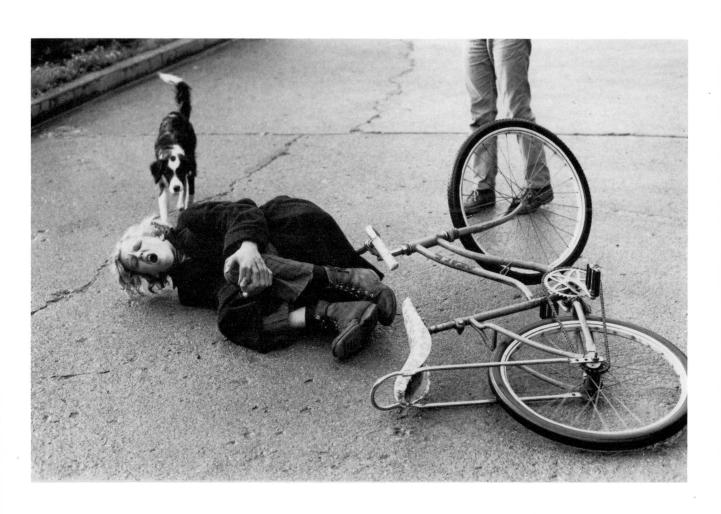

Before his vision "handicap" was detected and corrected with glasses, he had time to learn the world as a complex of interrelated blurs of energy. So he did not begin his training as most of us do, with emphasis on getting details straight. Fuller grew up to become one of the most comprehensive and global thinkers of this century, and has spent his life teaching entire generations whole-systems thinking. His basic research is made up of details, but his mind remains omnidirectional and highly conscious of the fact that the world is movement. One of his many books is titled *I Seem to Be a Verb*.

During my early camerawork, I threw away accidentally blurred or over-exposed slides. One day, out of curiosity, I projected a few "flawed" pictures, blowing them up to three by five feet on the screen. Someone asked, "Did you do that on purpose?" as we marveled at the painterly quality some of these images had, as a few looked like impressionistic canvases from turn-of-the-century brushes. Some even had the feel of Van Gogh's passionate expressionism. I was tempted to say, "Of course!" From then on, I not only looked at my own accidents and "failures" with a more generous eye, but began tucking them away to age like wine. Re-examining them weeks or months later, after getting a little aesthetic distance from them, I found that some provided at least the foundation for creative expression. Others stood on their

own. Still others came alive when sandwiched with another "weak" photograph. (See color section.)

Soft focus or a moderate blur is useful in portrait work for recording the spirit-energy of a subject. Even in landscapes or still lifes it can achieve the effect of seeing with a touch of sleep in the eyes, and it lets the viewer experience the photographer's motion as he encountered the scene.

These are a few of the endless possibilities available for capitalizing on goofs. There are some mistakes we want to repeat, and in camerawork it is a joy to turn errors into tools for deepening the range of creative possibility.

# Photography as Illustration

The most potent force of photography is the credibility of its images. That old saw "Seeing is believing" contributed to the common belief that the camera does not lie.

Photography as illustration began almost with the invention of cameras. The earliest exponent of fine-art photography was J. E. Mayall, who in 1845 produced ten daguerreotypes illustrating the Lord's Prayer. The first book ever illustrated with photographs was Henry Fox Talbot's *Pencil of Nature*, which appeared in six parts during 1844–46 and consisted of twenty-four photographs of household goods and scenes on the boulevard. Talbot, as inventor of the calotype, used the book to demonstrate the practicality of his process as well as the use of photography for taking household inventory and to permit a viewer to wander by eye where he may not otherwise be able to travel. An explanatory note to the reader stressed the novelty of photography: "The prints in the present work are impressed by the agency of light alone, without any aid whatever from the artist's pencil. These are the sun's pictures themselves, and not, as some persons have imagined, engravings in imitation." From their earliest illustrative use, photographs were offered as objective records almost untouched by human hands.

The first documentary photographs were daguerreotypes of street people, made by Richard Beard, illustrating *London Labour and the London Poor*,

a social survey written by Henry Mayhew which appeared in 1851–64 and was the initial example of photo illustration used to invoke social consciousness for a popular audience.

In 1886 the ubiquitous Nadar devised yet another of his innovations, the photographic interview, on the occasion of the great chemist M. E. Chevreul's one-hundredth birthday. During the interview, Nadar's son Paul recorded the old man's animated expressions and gestures as the venerable scientist and color theorist explained his philosophy for longevity.

Modern photojournalism did not begin with *Life* magazine in 1936, but two years earlier with the English magazines *Picture Post* and *Weekly Illustrated*. They contained the work of Stephan Lorant, who later came to America, in 1940. His book *Lincoln: His Life in Photographs* was published in 1941, pioneering a new genre, the pictorial biography.

It was Felix H. Man who did the first reportage in color, with his 1949 photograph of the Thames River, a smoggy sunset at Chelsea. It was also the earliest low-light color photograph. Man was chief photographer on the *Picture Post* for some years. In 1951, he produced for *Life* the first night reportage in color and the first color photographs made by moonlight. These low-light pictures were made with long exposures, usually of ⅕ to ½ second, using a tripod.

Good writing is presumably vivid, and effective pictures are supposed to be worth a thousand words. Yet the flourishing market for photojournalism proved that combining words and pictures gave the public the "You are there" realism it wanted. Photojournalism's American heyday seemed to end with the suspension of *Life,* in 1972. Before that, other long-lived magazines of a similar kind, such as *Look,* reached many millions of readers and provided a mirror for people in every walk of life. One factor that apparently killed off these giant magazines was the massive circulations they built up over the decades. Rising production, handling, and mailing costs made weekly publication unprofitable. The trend now seems to be moving toward continuing photojournalism, but in smaller circulations to more specialized audiences. Europe and Asia, however, still support a great number of illustrated publications. And, of the early American pictorials, the monthly *National Geographic* continues to be a magnificent combination of color photography of animals, world-wide locales, and intimate portraits of every imaginable member of the family of man. And as the interest in photography as a personal art form increases, magazines of "popular photography" thrive.

Photographics have contributed to a new awareness of a number of realms, notably warfare, poverty, and ecology. The Crimean War was brought home to a complacent Europe; the American Civil War photographs stunned the

world; exposés of London sweatshop conditions and pictures of street urchins aroused legislators during the Industrial Revolution; photographs of the Dust Bowl disaster and other Depression horrors of the 1930s all made real the facts of life that would otherwise have gone largely unnoticed by all but those in the centers of suffering. A less dramatic "reportage" was made by Carleton Eugene Watkins when he photographed California missions and the Yosemite regions in the northern latitudes of that state. He used a specially constructed 18×22-inch camera; the resulting photographs inspired Congress and President Lincoln to protect the region, by establishing the National Park System.

All these examples of illustration are uses of "straight" photographic imagery. Today's innovator can transform images to increase impact in a social statement, or for sheer entertainment, or in the service of pushing out aesthetic borders. Because of the plethora of pictures seen every day, sometimes for hours on end via television and movies, it often requires not only an outstanding image to attract attention, but a unique transformation of normal imagery into a refreshing visual oasis.

Putting a soft-focus or a patterned filter over the lens is a basic form of in-camera manipulation. One well-known pattern is the star-burst filter, especially useful in photographing used cars, as any high point of light

bouncing off the waxed metal glints like the sun on a film star's tooth! This rather gimmicky filter will, however, add magic where magic is due, if used conservatively. The soft-focus filter finds a wider application, lending a gentle diffusion to landscapes and portraits. With color film, it diffuses the most pedestrian scenes into pointillistic canvases. Instead of carrying around such a filter, I use the "hot breath" technique, simply breathing on the lens (protected with a neutral UV filter) as though for cleaning eyeglasses. As you shoot, the mist evaporates in stages, giving a choice of densities. It will not work in dry climates such as deserts.

It is simple to achieve a one-color approach to a subject by covering the lens with colored cellophane. By use of infrared film, without filters, white skin will look like translucent ivory, blue skies will be bluer, and green growing things will become various tones of red and purple, all of which contribute to a startling transformation of the familiar. Infrared film with filters pushes things out even farther.

Black velvet behind a still life, a nude, or a portrait subject boldly isolates forms, surrounding them with a background of deep, featureless space. And for other worldly-effects, Mylar is like a fun-house mirror, and can be tacked on a wall or hung in the breeze. This light weight mirrorized plastic sheeting is available in colors, although silver is best for photographic applica-

tions. A whole wall can be covered, or just a square foot or so can be carried around and set up on location. This reflective material distorts geometry, reflecting "underwater" or dream-space images. By pinning such a sheet to the wall, stress lines can be formed between the securing tacks, as the artist imposes diagonal geometries on the composition, or ripples the surface into waves. It is also a perfect material for bouncing available light onto a subject. Crushing it creates explosive clusters of colored reflections.

It should be noted that during the first fifty years of photographic history, most off-beat or imaginative photographic processes were described in books that regarded such innovations as mere tinkering or parlor pastimes. Finally, a book published in 1893, *Les Récréations Photographiques,* by Bergeret and Drouin, suggested that serious artists or scientists do not actually suffer a loss of dignity when they learn even from recreational activities!

Probably the first collection of photographic art in which most traditional rules of photo imagery were ignored was the 1925 Bauhaus publication *Painting, Photography, Film,* which included photograms made in the dark-room by placing objects on photosensitive paper ("cameraless photography"), double exposures, and photomontages (collages).

In addition to the use of photography as published illustration, the photo-miniaturization technique mentioned earlier regarding cityscapes is a fascinat-

ing tool. Here is a typical application: The photographer takes pictures of the four walls of one or a number of rooms, including objects, furniture, and perhaps people. After prints are made, each wall is cut out and glued upright to a "floor," which may also be a photograph. By constructing a three-dimensional model of the environment, the situation is seen from a dramatic overview. And there is nothing quite like having your house in your house! A less ambitious project is to photograph individual objects, such as a potted plant or a chest of drawers, and place the cutout image near "the real thing," as a visual echo. Also, children love paper dolls and other tiny things which can be made from elements in their own lives through photominiaturization.

The photocollage is yet another field for reaching beyond the normal scope of photographics. Cutting elements out of larger pictures, isolating them, and collecting a tree here, a hand there, clouds, shadows, reflections, and parts of other things so fragmented that they are no longer identifiable, the designer makes deposits in an "image bank." As the "account" fills, it becomes a visual "alphabet" from which elements can be selected and assembled into realistic statements or abstract expressions. Gluing together such images and textures is an unlimited field for exploring images beyond images.

We have reached the realm of creative imagery known as the art of sandwiching. The photographic sandwich is the closest thing to ripping through

the relativity of time and space with a camera. A physicist once remarked that the reason there is time is so everything won't happen at once, and there is space in order that everything won't happen all in the same place! The sandwich accumulates time and space in surrealistic layers. With two (rarely more) transparencies or black-and-white negatives directly on top of each other in a single mount, an elephant can bathe in a teacup, a person can meet himself on the beach, or nearly any other "separate reality" can come into view. (See color section.) Taking slides (the more convenient form) and trying them out on top of one another on a light-table absorbs the imagination in an infinite number of possibilities for manipulating the real or plunging into the surreal. As mentioned earlier in the discussion of creative accidents, photographic sandwiches frequently incorporate single slides that otherwise would be discarded for lack of content or technical sufficiency.

Often, surrealism has been mistakenly defined as visions reflecting the dreamworld. That is only half true. The surrealists themselves, such as André Breton, who spurred modern artists into getting more in touch with the flow of inner vision, considered surrealism as a *super realism*, a unification of *both* the unconscious dreamworlds *and* the stuff of everyday life. By superimposing a bird over the forehead of a woman, she can seemingly contain the spirit of the higher world. With sandwiches, anything can happen, and a few

hours at the light-table can easily take the eye beyond clock time and beyond even the historical frame. If using just one hundred slides, the combinations possible (aesthetics aside) are 9,900 pictures!

But every slide, of course, will not work in this technique. The most effective elements for building sandwiches are pictures that have a certain amount of negative space, allowing other images to show through without the confusion of images from the second slide interfering with its readability. For example, a shot through a window frame on a cloudless day is perfect to superimpose on the face of a white rabbit. Together, it will appear that a 500-pound rabbit is looking in on you. The negative space of the window panes allows the fuzzy features to show through clearly.

Purists consider sandwiching, the use of funny filters, and so forth, as just so much gimmickry, and overreliance on any technique can easily decay into chaos and a substitute for ability. But with the essentially limitless approaches available in-camera, at the light-table, and in the laboratory, any one method of exploring the growing edge of vision is at least a counterpoint to straight photography, and can often be a source of personal break-through and an extension of the creative horizon.

Mentioned here have been but a few of those methods. The darkroom and color lab are where solarization, tone-line printing, color reversals,

and other extraordinary things happen, which would require a separate volume and can only be learned "hands on."

What we are concerned with is not gimmickry, but creative freedom. In his first surrealist manifesto, André Breton emphasized the word liberty as the heart of the surreal revolution. For the artist, this means liberation from the rules of art. Van Gogh and Picasso are examples of such courage, as, certainly, on their journeys to great vision they toyed with whatever struck their fancy.

"Illustration" means a clarification or explanation. Photography examines and clarifies life, and adds dimensions of meaning to reveal possibilities that must go unnoticed without it.

# The Magic Lantern Show

The room is dark. Music enters the space, images rise and pass before the audience, hallucinating scenes of another time and place, absorbing awareness and transporting emotions.

After recording a multitude of individual photographs, moments of recognition, and stopping the world, orchestrating them into a program of action stills is an expansive sharing of the visual adventure. Whether a story, a travelogue, or a session of pure aesthetic eye-joy, slide shows always find an eager audience.

The common form of magic lantern show includes one projector and a single screen for a simple transfer of information. Multiple projectors throwing images on a number of screens, walls, or nude bodies, produce astounding effects. In such a sensory surround, the audience can see and absorb, or actively participate without "paying attention" in the usual, linear sense. But as we are already living in a cacophony of information in the industrialized world, a simple procession of pictures with, at the most, two projectors and a single screen should be adequate for most purposes.

We have been concerned primarily with the art of seeing and with the individual photograph. The slide show is the arena where the photographic magician choreographs a dance among images. The late French architect Le Corbusier expressed the vital discipline of co-ordinating elements into new

expressions of aliveness: "I demand of art," he wrote, "the role of challenger . . . of play and interplay, play being the very manifestation of the spirit."

An aesthetic accessory that attaches to two projects is the dissolver, which gradually fades images on and off for a predetermined period of time, giving a graceful flow to the sequences. Different forms, symbols, and structures can therefore be born out of one another, as a series might show babies' faces evolving into those of children, and so on through old age. Or, again in the linear mode, a macro photo of a drop of water can evolve into a puddle, a stream, and then an ocean.

Watching images in relative silence is "flat" compared to the involvement achieved when music complements or counterpoints the program, and ordinarily there is great latitude in selecting or creating sound tracks for magic lantern shows. Because moving stills for an audience borders on the cinematic, an example from motion pictures is appropriate: Recall the short educational films widely used in schools illustrating the germination of seeds and the subsequent stages of budding and growth of plants through the use of time-lapse photography. A rose is being born, pushing into the sunlight, blossoming, and dying in a matter of seconds. If jazz is played behind it, the rose seems frantic; with an old rhythm-and-blues song, it will appear risqué; and the same images projected with religious music will make the pictures feel like a

divine revelation. This synthesizing function of the brain brings sights and sounds into a homogenized *gestalt* whenever music and pictures are combined, usually giving the sense that the rhythms of eye and ear data are remarkably in synch. Of course, the more unrelated they are in the logical sense, the more ironic the effect.

Pacing slides through the machines, and the fade-in fade-out timing of the image-overlap when using the phaser is a delicate area. The generation gap has shown itself to be a sensory gap, as the eyes and ears of today's children have been educated by an accelerating media input. Generally, the younger the audience the more easily they will read swiftly moving stills.

The earliest form of "slide" projector, the "magic lantern" of the mid-seventeenth century, was lighted by a flame that was reflected in a mirror, projecting the image of a glass plate onto a screen. The fashionable salons of the time adopted this hallucinatory entertainment which was also a sensation at popular fairs. The device evolved into the "phenakistoscope," which gave the illusion of motion and later developed into cinematic inventions. The love for the persistence of vision grows with every new application, from cinema and television to light shows and recently laser projections in three dimensions. There is obviously a deep longing throughout the world to be, as one film critic has called it, "spellbound in darkness."

# Visual Meditation

Infinity, the vanishing point, is no longer down the railroad tracks or out on the horizon but here in the self of the seer. When contemplated through a lens, the world takes on a somehow clearer aura, partly because of the glass but especially because of the focus and concentration of camerawork. The young Buddha, finding himself nodding to sleep beneath a tree, cut off his eyelids in order to remain ever wakeful, and where they fell grew a new plant—tea. That is why, say the Buddhists, we drink tea to stay awake!

Yielding to forms in the camera art of free association, intuitively receiving images that beckon attention and contemplation, can become a meditation beyond photography. Such surrender required for the awakened eye to guide the camera naturally evolves into a form of prayer. When the camera stops the world in a click, or a photograph stills it in an image for contemplation, it is not stopping the world but stopping ourselves, coming to rest in timeless recognition. "The mind is unchanging: only its reflections change." These words from the *Surangama Sutra,* and the following from Zen, speak of the peaceful balance of mind and heart, between action and stillness: "To see is the meaning of life, not to see something, but merely to see."

Identifying with what is photographed in open acceptance offers a hint about creativity: It is similar to the experience of reading something so engrossing that you feel you are actually *writing* it. In the photographic ex-

perience, it comes as the feeling of practically creating what you see. Thomas Traherne, the seventeenth-century Christian mystic, wrote, "If thine eye is single, thy body is full of light." In such moments of unity, there is no seer and thing seen, as all such categories simply vanish.

We can take what we know about how a "thing seen" affects us and concentrate on one particular image, symbol, or scene. Forgetting the camera, we smile at beauty, which is always fleeting as a bird that miraculously lands on the outstretched palm. The hand remains open, lest it grab and crush. *Using the camera well includes not using it at all.*

There are as many ways to meditate as there are methods of concentration. There is sound meditation, so gorgeously demonstrated by the sitar or Gregorian chant, and meditations on odor with incense or perfumed oils. Visual meditation takes many traditional forms, including gazing at the burning tip of an incense stick, or gazing on the face of the Buddha or upon a rose.

The photographer may wish to practice techniques more suited to his or her individual needs. One might be cloud-gazing. Viewed lying on the beach, in an open field, or on a mountaintop, cloud formations contain images as if bubbling within a crystal ball. Watching with as little blinking as comfort will allow, faces begin to appear, animals come into being and disappear,

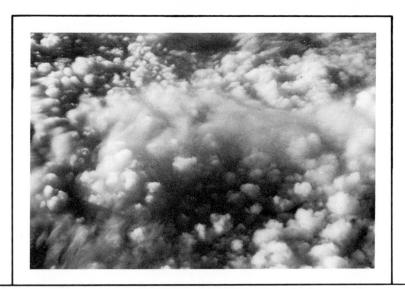

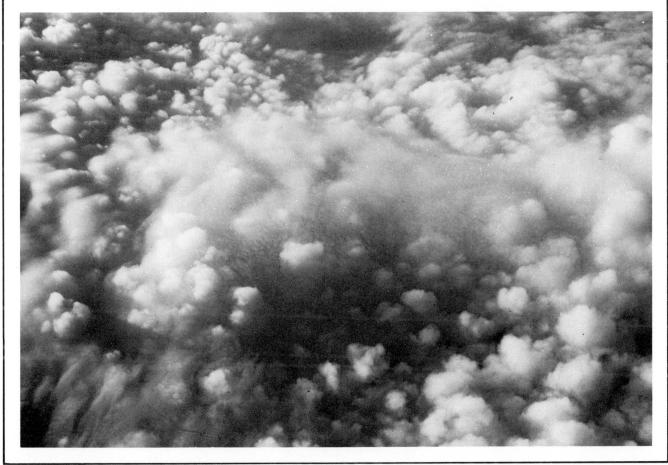

and celestial sculptures beyond recognition come into view. The daily practice of centering in *slow time* over a period of months will develop these natural abilities.

Another life-energy meditation, this time at the household level, is with a common potted house plant, the coleus. These widely available leafy beings are so sensitive to varying conditions that if not watered regularly in the right amount they droop dramatically. Beginning with a sagging coleus, place yourself comfortably before it and pour a small glass of water into its soil. In uninterrupted solitude, watch it until the leaves are standing up again. A healthy plant will revive completely in a short time, sometimes within twenty minutes to a half hour. One researcher who studies plant reactions to human emotions was asked by an interviewer what advice he could give for developing a green thumb. "All you need," he replied, "is to believe in your heart that all plants are conscious. The rest is easy."

Another graceful escape from the human time frame is watching the ballet inside an aquarium, or the progress of garden snails. The opportunities for visual meditation are unlimited. For a few minutes or hours, we surrender to something outside ourselves, yet completely a part of us. And that something is equal to what Blake celebrated with "To see a World in a grain of sand,/and a Heaven in a wild flower." Whatever is chosen for meditation be-

comes for a time our master, stabilizing and impressing us as vibrantly as a respected teacher.

It cannot be overemphasized that we become what we behold. As the lungs need air, the eyes need images. After passing many hours among random events and imagery, the shrine of personal beloved images is a sanctuary beyond the chatter of thinking and the melodrama of daily involvement.

An illustration of visual meditation in action is the tale of an artist who passed seventy years seeking spiritual realization through painting landscapes. When at long last he experienced every stroke of his latest work with harmony and satisfaction, he puts his brushes on the easel and walked down the winding road through the scene on the canvas and was never seen again.

# Afterimage

After probing appearances and deepening vision through the "second sight" of photography, the photographer emerges as one in whom experience is a perpetual communion, with or without the lens.

Suddenly, in the midst of peak moments of joyous discrimination, everything unique begins to look like everything else, as the journey of conscious vision completes the cycle, from seeing the tiniest particulars to the embracement of the All.

With this enlightening "shock of recognition" comes the pure energy of Being. The appearances of the world implode into one great Sameness in the vibration of Eternal Being known in the awakening eye.

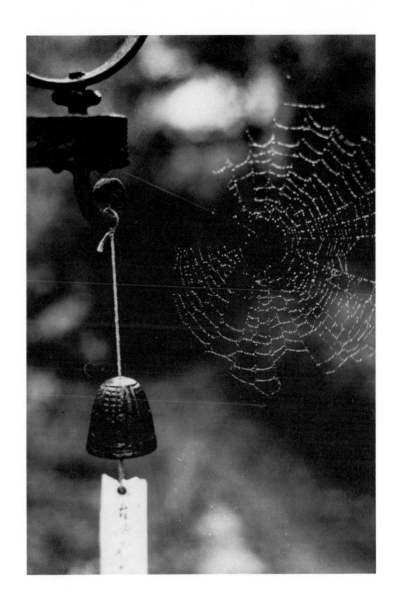

# THE PHOTOGRAPHS

*(continued)*

# IN COLOR